IMAGES
of America

CHARLOTTE
AND THE
CAROLINA PIEDMONT

D1473184

IMAGES
of America

CHARLOTTE
AND THE
CAROLINA PIEDMONT

Tom Hanchett and Ryan Sumner
Levine Museum of the New South

ARCADIA
PUBLISHING

Published by Arcadia Publishing
Charleston, South Carolina

Printed in the United States of America

Library of Congress Catalog Card Number: 20030110506

For all general information contact Arcadia Publishing at:
Telephone 843-853-2070
Fax 843-853-0044
E-mail sales@arcadiapublishing.com
For customer service and orders:
Toll-Free 1-888-313-2665

Visit us on the Internet at www.arcadiapublishing.com

CONTENTS

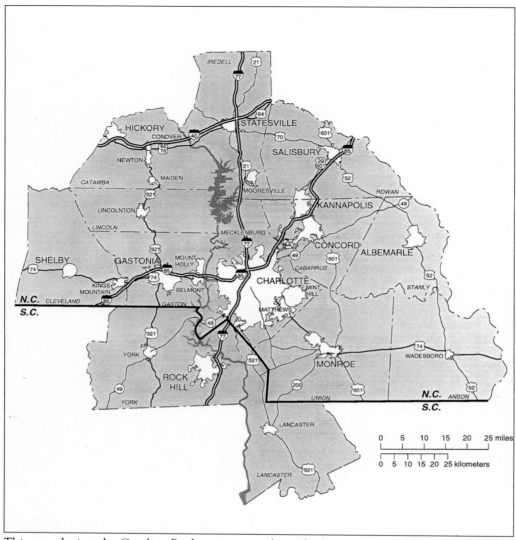

This map depicts the Carolina Piedmont surrounding Charlotte.

On the cover: Osmond Barringer loved dreaming up publicity stunts for Charlotte's newspapers. On October 24, 1919, Barringer (right) and Lt. L.E. Shealy (left) helped Miss Bennie Williams (second from left) become the first woman to fly an airplane over the city. Mrs. Barringer (with the child) rode as a passenger in another airplane to act as a chaperone. (Courtesy of Elizabeth Ragby.)

INTRODUCTION

From field, to factory, to finance—this is the trajectory of Charlotte and the surrounding Piedmont in the New South era. Once a land of small farms and isolated courthouse villages, this area has been knit together into an "urban region" that is centered on the second-largest banking city in America.

What is the New South? After defeat in the War Between the States, the once-rural South set out to rebuild itself in a fresh image, as a region of cities and factories. Writers, including South Carolina's Edwin DeLeon and Georgia's Henry Grady, began using the term "New South" for this vision. Slavery was gone, and both the economy and society had to be reinvented. That spirit of reinvention still defines the New South today.

This book begins with a quick look at the Old South, when the Carolina Piedmont was known as the "backcountry" because of its isolation. Piedmont, meaning "foot of the mountains," refers to the broad band of rolling red clay hills that sweep across the Carolinas, bounded on the east by the flat and sandy coastal plain and on the west by the rising mountains of the Blue Ridge.

From the Old South, we turn to the New South and its many reinventions. In the 1850s the railroads penetrated the Piedmont, then in the 1860s the Civil War wiped out the old plantation areas closer to the coast. The "backcountry" came into its own. Cotton farmers brought crops to Charlotte and the surrounding railroad towns of Rock Hill, Fort Mill, Lancaster, Gastonia, Lincolnton, Huntersville, Statesville, Concord, and Monroe. Textile mills opened, drawing families away from the land and making Charlotte the trading hub for America's cotton manufacturing region. People shopped at Belk department stores, listened to WBT radio, and bought new-fangled electric appliances from Duke Power. Federal investment beginning with the 1930s New Deal and the Civil Rights Movement of the 1960s brought the South into the modern era. Today this once-poor region is an economic magnet, attracting new residents from around the globe.

If you enjoy this book, you'll enjoy visiting the exhibit upon which it based. "Cotton Fields to Skyscrapers: Charlotte and the Carolina Piedmont in the New South," was named the best new exhibit in the southeastern United States by the South East Museum Conference. See it at the Levine Museum of the New South, corner of North College and East Seventh streets in uptown Charlotte, or check out the website at www.museumofthenewsouth.org.

Tom Hanchett and Ryan Sumner
Levine Museum of the New South

One

THE OLD SOUTH
1740s–1860s

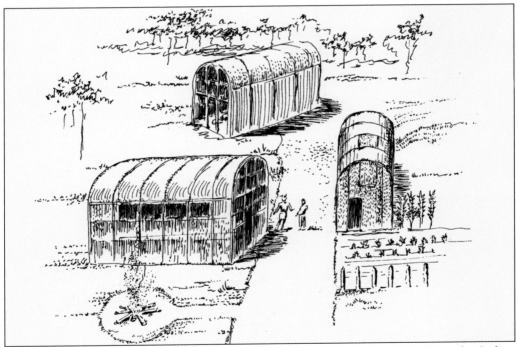

The original inhabitants of the Carolina Piedmont were members of the Catawba Indian Nation, and their dwellings are depicted here. In the 1740s, white Scots-Irish Presbyterians and German Lutherans began arriving in the area, migrating south down the "Pennsylvania Wagon Road." They established a settlement at the intersection of two Catawban trading paths—now Trade and Tryon Streets. The Catawba suffered mightily from smallpox and warfare, such that their numbers dwindled from more than 5,000 in the early 1700s to less than 100 by the 1820s. Today, there are over 1,200 Catawba, many living on or near reservation lands located outside Rock Hill, South Carolina. Visitors are welcomed at the Catawba Cultural Preservation Center. (Sketch courtesy of Jack O. Boyte.)

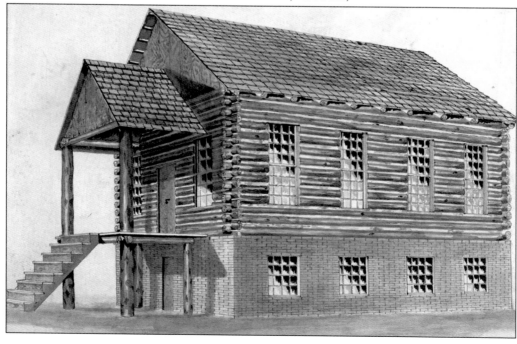

Founded in 1769, Charlotte Town was named after Charlotte Sophia of Mecklenburg-Strelitz in Germany, the wife of British King George III. Today, Charlotte is still known as "The Queen City" because of this early effort by town fathers to curry favor with the Crown. (Portrait by Sir Thomas Gainsborough.)

Charlotte Town community members led by Tom Polk used their own money to erect a courthouse right in the center of the intersection of Trade and Tryon Streets, a move that persuaded the colonial government in New Bern to declare Charlotte Town Mecklenburg's county seat. From the courthouse steps, the Mecklenburg Declaration of Independence—in which the county declared itself free from British rule more than a year before July 1776—was supposedly read aloud to the community on May 20, 1775. The original documents were lost in a fire and historians debate what actually happened. (From ink and watercolor drawing by D.A. Tompkins; courtesy of the Robinson-Spangler Carolina Room, PLCMC.)

During the American Revolution, General Cornwallis of the British forces marched on Charlotte Town on August 26, 1780, expecting to easily capture it and enlist Loyalist volunteers into his ranks. The task proved more difficult than he hoped when a small band of rebel militia under the command of William R. Davie (right) began firing on Cornwallis from defensive positions under the courthouse and behind rock walls. Although the group was hopelessly outnumbered and was eventually defeated, they held 2,000 British troops and cavalry briefly at bay. The nasty reception led Cornwallis to call Charlotte a "hornet's nest," a nickname the city wears proudly to this day. (Courtesy of the U.S. Army Center of Military History.)

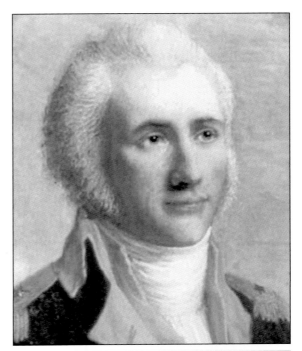

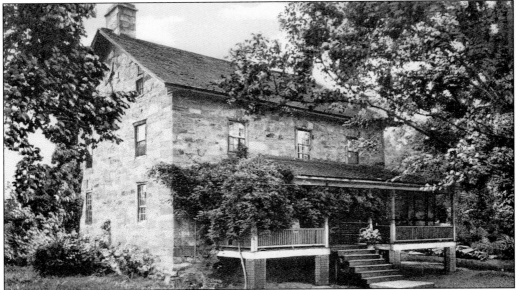

Hezekiah Alexander was an important Charlotte Town leader and one of its foremost patriots. Alexander held several important offices in the revolutionary government, including being a delegate to the April 12, 1776 North Carolina Constitutional Convention in Halifax that adopted the "Halifax Resolves," which instructed the North Carolina delegates to the continental congress to vote for independence—the first official action by a colony calling for independence. His stone house stands today as one of Charlotte's most important historic landmarks and is cared for by the Charlotte Museum of History. (Courtesy of the Robinson-Spangler Carolina Room, PLCMC.)

Historic Rosedale on Charlotte's North Tryon Street (above), as well as Latta Plantation off Beatties Ford Road in northern Mecklenburg County, give a sense of how planters—those families who owned 20 or more slaves—lived in the Carolina Piedmont. (1838 advertisement; courtesy of the Robinson-Spangler Carolina Room, PLCMC.)

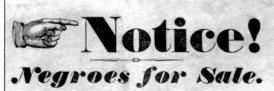

☞ **Notice!**

Negroes for Sale.

On the 18th day of December

next, at the Plantation of the late *Obedience Dinkins*, dec'd. I will offer for sale

12 likely NEGROES,

viz: 5 *Men*, 3 *Women*, 2 *Boys*, and 2 *Girls*, a quantity of

Cotton, Corn and Fodder, 1 Horse, 2 Cows and calves, 1 Cotton Gin & Gearing, Farming Tools, Household & Kitchen Furniture,

with other articles not mentioned. The sale will continue from day to day, until all are sold. A credit of twelve months will be given. Bond and approved security required.

Sam'l. Cox, *Executor.*

White Hall, N. C., Nov. 19, 1838.

N. B. All persons having claims against the late *Obedience Dinkins*, dec'd., will present them properly attested within the time the law directs, or this notice will be plead in *bar* of their recovery.

SAM'L. COX, *Executor.*

Introduced to Mecklenburg County in 1764, slavery was a very real part of life in Charlotte and the Carolina Piedmont. In 1790, slaves made up about 14 percent of the backwoods population. By 1860, records show 6,800 slaves living in the county—40 percent of the total population. There are also listed 293 free-blacks; the occupation of most of these is given as common laborer, but a handful are listed as barbers, blacksmiths, carpenters, iron molders, and painters. (Courtesy of UNC Charlotte, Special Collections.)

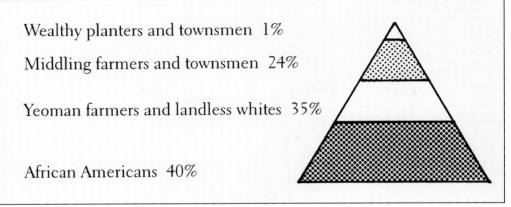

Wealthy planters and townsmen 1%

Middling farmers and townsmen 24%

Yeoman farmers and landless whites 35%

African Americans 40%

Compared to coastal and Deep South regions, the Piedmont had few large slaveholders. Rocky rivers made it hard to get crops to market, so plantations stayed small. In Mecklenburg County, only one family owned 50 slaves on the eve of the Civil War. However, nearly a quarter of Mecklenburg residents were slaveholders, with more than 800 households owning between one and 20 laborers. (From *Sorting Out the New South City: Race, Class and Urban Development in Charlotte.*)

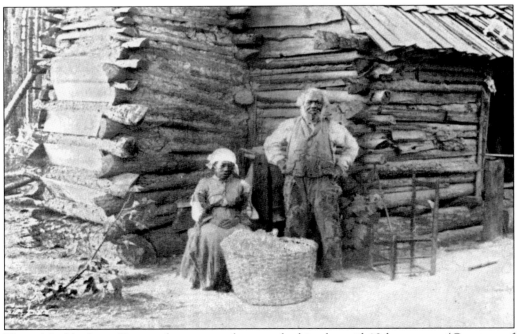

These Mecklenburg County slaves were photographed in the mid-19th century. (Courtesy of UNC Charlotte, Special Collections.)

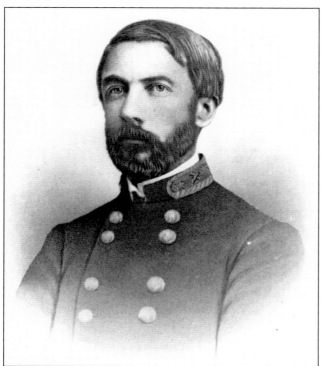

Like his brother-in-law Gen. Stonewall Jackson, Confederate general Daniel Harvey Hill was a teacher before the war, first at Davidson College and then as the superintendent of the North Carolina Military Institute. When South Carolina seceded from the Union on December 20, 1860, Hill urged his students not to leave school until war became inevitable: "Recruiting sergeants, with their drums and fifes, try to allure by 'the pride, pomp, and circumstance of war;' they never allude to the hot, weary marches, the dreary night-watches, the mangled limbs, and crushed carcasses of the battle-field." (Courtesy of the North Carolina Department of Cultural Resources.)

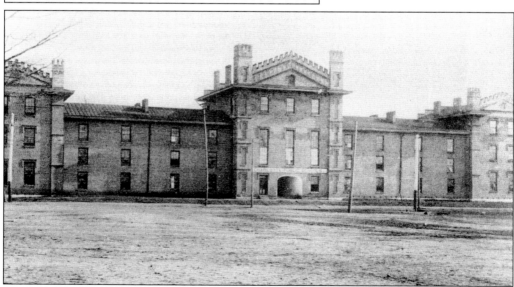

The North Carolina Military Institute opened in the fall of 1859, admitting boys aged 12 to 15 for its primary department and young men from 15 to 21 years in its scientific department. The curriculum was modeled on West Point's and by all accounts Superintendent Hill ran a very strict operation. The school closed with the outbreak of the Civil War and was used as a military prison during the conflict. Later, the building became a public school. It stood near today's Dowd YMCA on Morehead Street but was demolished in the 1950s. (Courtesy of the Robinson-Spangler Carolina Room, PLCMC.)

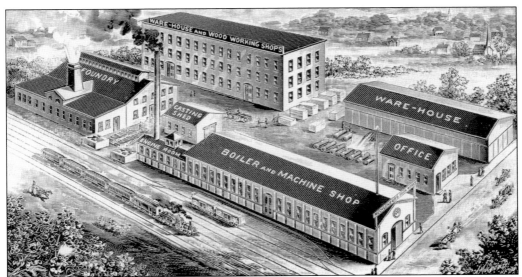

Because of likely capture by Union forces, the Confederate Naval Yard was moved from Norfolk, Virginia, to Charlotte in the summer of 1862. The Confederates commandeered the Mecklenburg County Iron Works (above) on East Trade Street beside the recently completed North Carolina Railroad. More than 300 workers produced mines, anchors, gun carriages, propellers and shafting, and even marine engines for the Rebel Navy, and sent them to the coast by rail until operations ceased in 1865. Charlotte also boasted the Mecklenburg Gun Factory, which made small arms, and the Confederate State Acid Works, a producer of sulfuric and nitric acids for telegraph batteries and percussion caps. (Courtesy of the Levine Museum of the New South.)

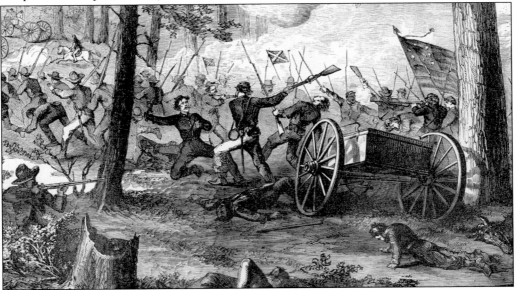

No major battles were fought in or immediately around Charlotte. Although the city was unscarred by the ravages of war, the people suffered mightily because of the conflict. Mecklenburg County supplied 21 companies—around 2,713 soldiers—to the Confederate cause. Many of these men died from battlefield wounds or disease. Others returned home maimed or with their souls broken by the horrors they had witnessed. (Courtesy of the Levine Museum of the New South.)

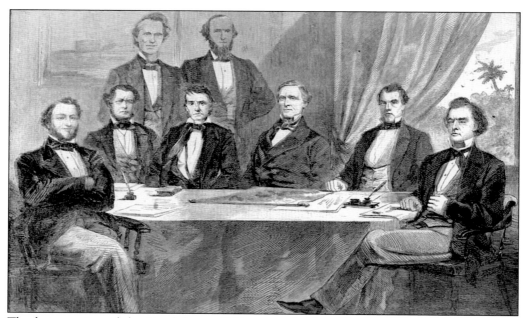

The last meeting of the Confederate Cabinet was held in Charlotte on April 24, 1865, in the grand home of William Phifer on North Tryon Street. The scene probably resembled this engraving of an earlier meeting, except that Secretary of the Treasury George Alfred Trenholm was sick and confined to Phifer's bed. It was also in Charlotte on April 14 that Confederate president Jefferson Davis heard the news of President Lincoln's assassination. Davis responded, "I certainly have no special regard for Mr. Lincoln; but there are a great many men of whose end I would much rather have heard than this. I fear it will be disastrous for our people and I regret it deeply." (From *Harper's Weekly*, 1861.)

Mary Anna Morrison Jackson grew up near Charlotte. She married Thomas (later "Stonewall") Jackson in 1857. Two of her sisters also married Confederate generals. Mrs. Jackson spent the war in Charlotte, living on West Trade Street after her husband was killed at Chancellorsville. Mrs. Jackson became an iconic figure of near religious adoration representing the Lost Cause. The city published postcards of her house and made her the guest of honor in each April's Confederate Memorial Day activities. (Courtesy of the Robinson-Spangler Carolina Room, PLCMC.)

Two

THE "NEW SOUTH" BEGINS
1860s–1920s

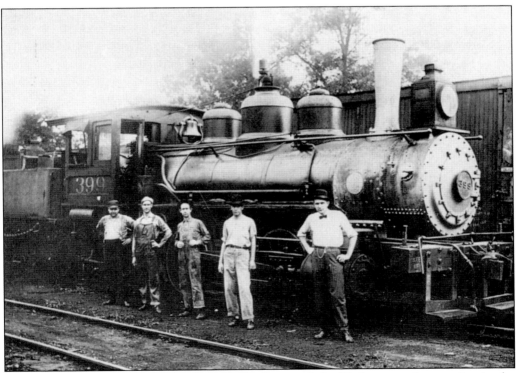

Railroads and the Civil War transformed Charlotte and the Piedmont region starting in the 1850s and 1860s. Because of the new railroads, Piedmont farmers could now raise cotton and sell it to northern mills. Would this risk bring reward? With the defeat of the Confederacy, African Americans became free citizens, but how would they live and work in the years after the Civil War? Southerners struggled to reinvent their rural world as a "New South." (Courtesy of the Robinson-Spangler Carolina Room, PLCMC.)

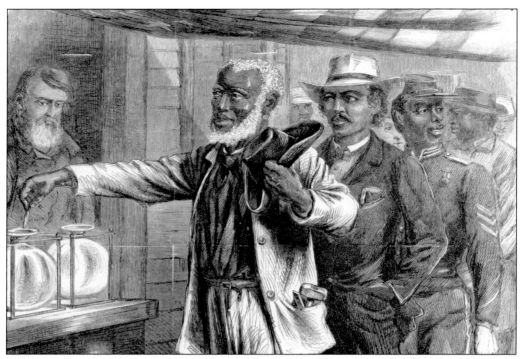

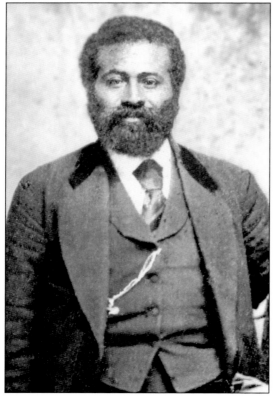

Reconstruction in the decade after the Civil War was a time for economic rebuilding—and the start of years of conflict over who should vote. Freed slaves could now cast their ballots. And for the first time, all white men received full political rights. (Prior to the war, owning land had been a requirement in both North and South Carolina.) Both changes made the old planter elite very uncomfortable. (From "The First Vote," *Harper's Weekly*, 1867.)

Fredrick A. Clinton was born in slavery c. 1834. His master, white planter and lawyer Ervin Clinton, educated the boy and taught him the basics of managing the Clinton plantation near Lancaster, South Carolina. F.A. Clinton served the 1868 convention that wrote South Carolina's Reconstruction Constitution. Lancaster County elected him to the South Carolina Senate in 1870, 1872, 1874, and 1876. (Courtesy of Theodora Smith and Mary McKey.)

One controversial issue that Reconstruction governments pushed was the creation of public school systems. In the Old South, public schools had been rare; the planters who controlled the government saw little need for such expenses, since they sent their own children to private academies. African-American leaders, such as Robert Brown Elliott of South Carolina (right), and many whites strongly supported public schools. But when Reconstruction governments were ousted from power in the 1870s, school funding was all but eliminated. (Courtesy of the Schomburg Center, New York Public Library.)

The men who had run politics before the Civil War hated losing power under Reconstruction. They started secret groups, such as the masked Ku Klux Klan (seen below with a North Carolina victim in 1871), who used threats, beatings, and murder to terrorize new voters, especially African Americans. Klan activity was strong in the Carolina Piedmont, and it helped put old-line leaders back in control by 1877. (Courtesy of the North Carolina Department of Cultural Services.)

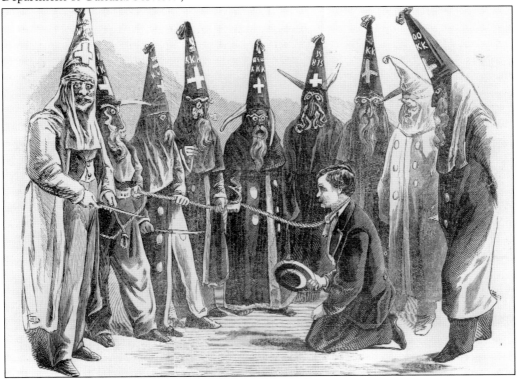

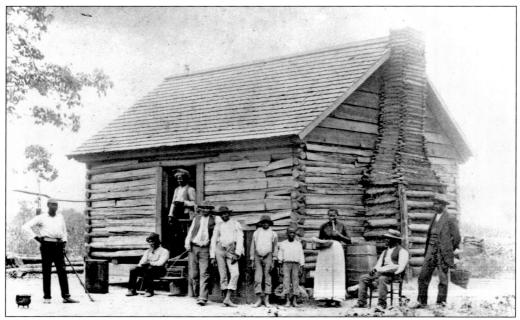

Black ex-slaves—who had no money at the Civil War's end—made rental agreements to borrow land, seed, tools, and mules for plowing. Landowners insisted that they grow cotton as a cash crop. By 1890, three of every four African-American farmers were tenants on someone else's land. Here a family of Mecklenburg County tenant farmers stands with their home, c. 1900. (Courtesy of the Robinson-Spangler Carolina Room, PLCMC.)

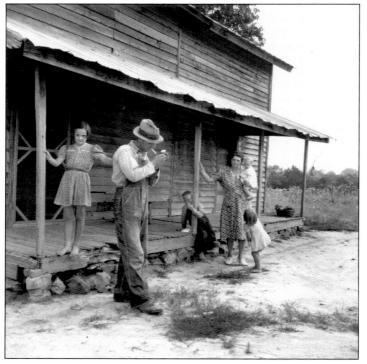

Whites with small farms, who had once grown only what they needed to eat, took out loans and planted cotton during the 1860s and 1870s. But, as output rose, cotton prices dropped. Farmers unable to repay their debts lost their land. By 1890, one of every three white farmers was a tenant on someone else's land. (Photo by Dorothea Lange, North Carolina, 1939; courtesy of the Library of Congress.)

Cotton became the cash crop that defined Piedmont agriculture in the New South. Civil War scarcities created a boom market for the fleecy plant, and the Piedmont, with its new railroads ready to transport crops to market, turned to cotton farming in a big way. But soon the land began to wear out; farmers found that they needed to spend more and more money on fertilizer. (Courtesy of the Levine Museum of the New South.)

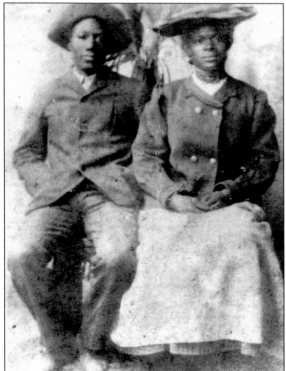

In 1899, Ishmael Ervin and his bride Rebecca began tenant farming in Charlotte's Steel Creek community. During the next 13 years, Rebecca bore eight children, all of whom took part in the constant work needed to keep the farm running. They lived on what they grew and made themselves but they did not lack for basic necessities. (Courtesy of daughter Masie Ervin.)

21

The Piedmont cotton farmer's year began with planting season in the early spring. When the ground was ready, farmers bought supplies from the store on credit, plowed the fields, and planted seed. (Courtesy of the North Carolina Department of Cultural Resources, Burke County, 1905.)

Late spring and early summer was time to "chop," or hoe, around the cotton seedlings to thin out the plants and get rid of weeds. Piedmont farmer Ben Robertson recalled, "In May we hoed and chopped and thinned. June we hoed and ran around the cotton with a plow. Through the long hot sultry July days we plowed and hoed some more." (Photo by Dorothea Lange, North Carolina, 1936; courtesy of the Library of Congress.)

Late summer was time for "laying-by" when men mended tools and repaired buildings and fences, while women gardened and canned vegetables and fruit. Here farmer John Gluyas escapes the burning sun with his family under a shade tree on his Charlotte farm off Mt. Holly-Huntersville Road. (Courtesy of John Oliver Gluyas III.)

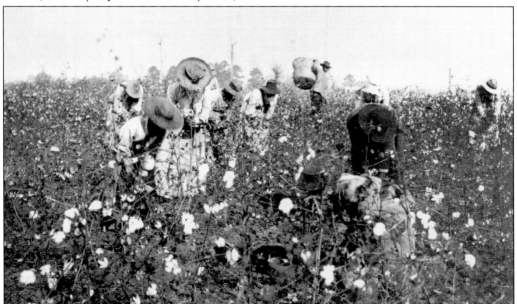

Cotton bolls matured and opened in fall. All family members worked long hours in the fields picking the cotton by hand. Then cotton was ginned, which removed the seeds before it was baled and shipped off. With the crop harvested, farmers settled debts with storekeepers or landowners. (Picking cotton near Charlotte, 1890s; courtesy of the Robinson-Spangler Carolina Room, PLCMC.)

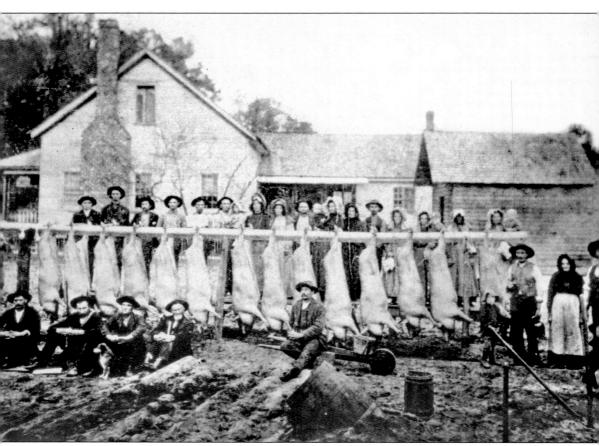

After harvest, the Piedmont farm families prepared for the coming winter. Children went to school, if there was one, while men and women mended tools and worked around the house. Winter's first frost was also the time to slaughter hogs, which were then hung upside-down to drain the blood, as seen in this c. 1809 Johnston County, North Carolina photo. Chitterlings (small intestines), livers, and other parts that could not be preserved were eaten quickly. Hams, shoulders, jowls, and sides of bacon were cured in a salt-filled barrel for weeks and then smoked with hickory wood. (Courtesy of the Johnston County Heritage Center.)

The cotton gin, invented by Eli Whitney in 1793, revolutionized cotton agriculture by replacing the labor of over 50 workers. The device removed the deeply embedded seeds from cotton. Raw cotton was fed into the top of the machine. Inside, revolving discs—similar to saw blades—separated the seeds from the fiber. (From D.A. Tompkins, *Cotton Mill Commercial Features*, 1899.)

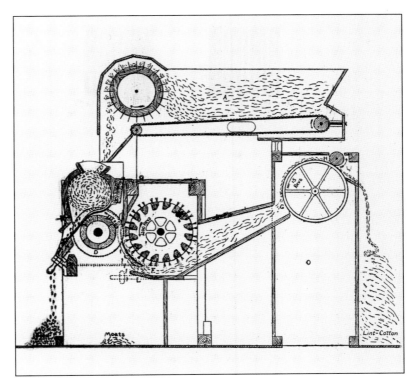

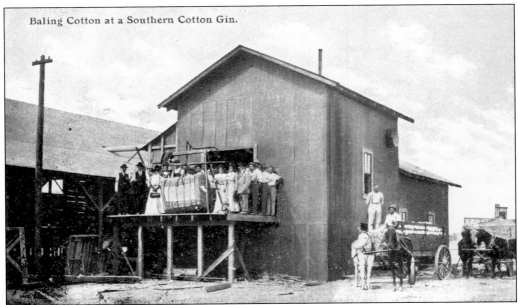

Baling Cotton at a Southern Cotton Gin.

In the early years of the New South, most Piedmont cotton farmers couldn't afford their own gins. Gin houses, often containing several ginning machines that could be utilized by a whole community of farmers, became a familiar part of the Southern landscape. These were often located along the railroad and operated by a general store. (Courtesy of the Levine Museum of the New South.)

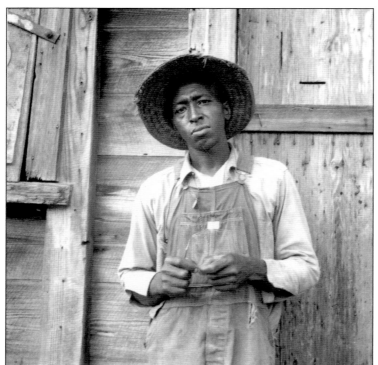

Work by the whole family was needed to operate the farm, and roles were clearly defined by gender and age. Men worked in the fields, cared for the most important animals, and repaired tools and buildings. They usually claimed the right to make decisions and assign chores. To bring in extra income, they might hunt, cut lumber in the winter, or take odd jobs. (Photo by Dorothea Lange, 1939; courtesy of the Library of Congress.)

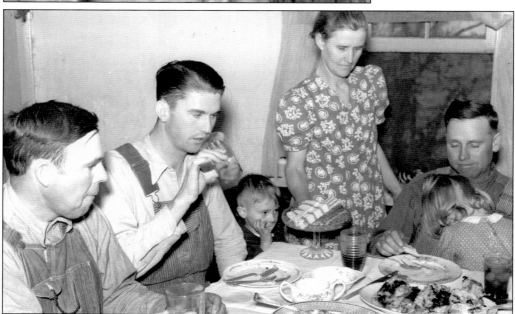

Women raised the children, cooked and cleaned, sewed and washed, made soap, and canned vegetables. Women often tended a "kitchen garden," where the family grew some of its own food. Men and children might rest or play on Sundays, or in the weeks after cultivation ended before harvest began, but farm women worked almost continuously throughout the year. (Photo by Marion Post Wolcott, 1930; courtesy of the Library of Congress.)

Children started helping on the farm as soon as they were able. They carried firewood, hauled water from the well, churned butter, and fed chickens and other animals, such as hogs. If a farmer had a cow or goat, children would milk these as well. Youngsters learned farming by working alongside grown-ups. (Photo by Dorothea Lange, 1939; courtesy of the Library of Congress.)

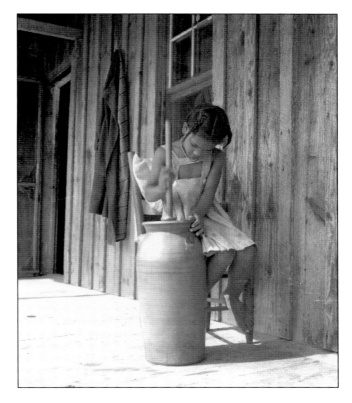

Housing for tenant farmers varied widely, but most lived in small, unpainted wooden cabins with neither plumbing nor electricity. Since tenants spent almost all of their income on rent, food, and supplies, they had little left over for furniture, books, toys, and other household items. Poor diet, dilapidated housing, and contaminated water often caused health problems such as pellagra, dysentery, and hookworm. (Courtesy of the Library of Congress.)

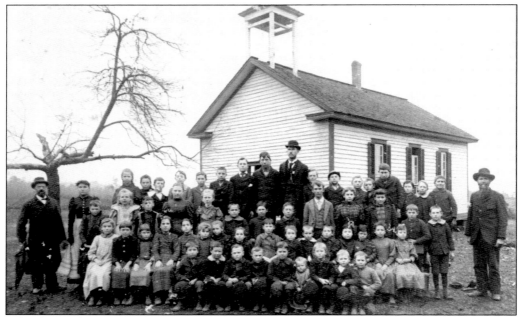

School was a low priority in a world where children learned work from their parents rather than books. School operated less than four months per year, compared to nine months today. Classes lasted a few weeks during summer laying-by, stopped to let children pick cotton, then ran a few weeks into winter. Education often ended at the eighth grade. One-room schoolhouses like this one in Newton, North Carolina, c. 1900, were the norm. High schools were rare in the rural Carolinas until the 1920s. (Courtesy of the Catawba County Historical Association.)

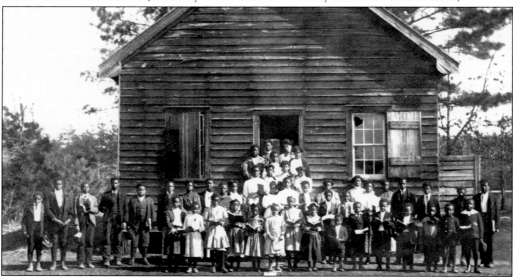

North Carolina gave schools for black children much less money than white schools. In 1915, the state spent $7.40 per white pupil, but only $2.30 per black pupil, compared to a United States average of $30 per student. This Columbus County school, seen in 1900, is typical of the one-room buildings that dotted the rural Piedmont. (Courtesy of the North Carolina Collection, UNC Chapel Hill.)

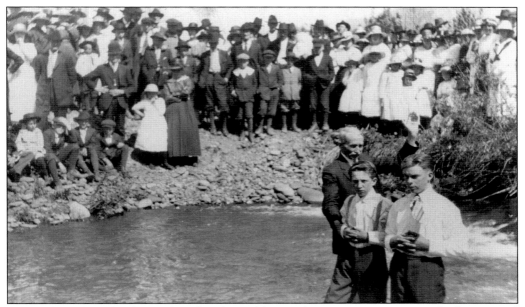

On Sundays, farm families gathered with neighbors to hear sermons on personal salvation and morality. Most Carolina country churches were Protestant and practiced fundamentalism—literal belief in the Bible. Social life revolved around Sunday services. Before and after the sermon, men could talk with other farmers about weather, prices, and crops, while women discussed children and home life. Young folks played and courted. (Courtesy of the North Carolina Collection, UNC Chapel Hill.)

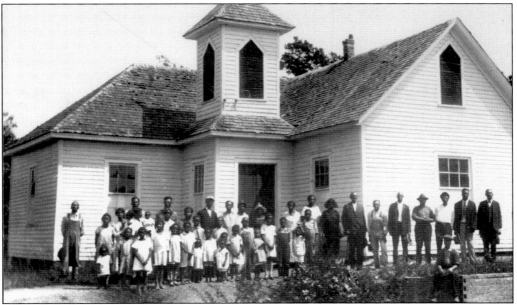

Church was especially important to African-American southerners because it was the only institution independent of white control. Here the congregation of the Rudisell AME Zion Church proudly stands in front of their building, c. 1925. (Courtesy of the Gaston County Museum of Art and History.)

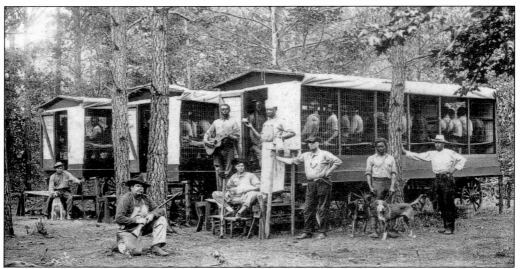

A "convict lease system" targeted African Americans in the late 19th century. Men convicted of, in many cases, racially motivated trumped-up charges were leased to work for private corporations. In the 1870s and 1880s, convicts laid most of the nearly 4,000 miles of railroad track in North Carolina. Mortality rates on the chain-gang were very high because without an economic reason to keep workers healthy, convicts literally could be worked to death. North Carolina was one of the last states to abolish this practice, considered by many to be worse than slavery. (Courtesy of the Library of Congress.)

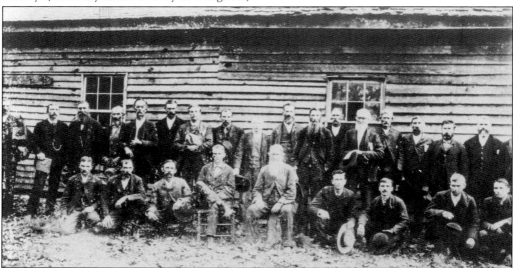

Cotton prices plummeted during the 1880s and 1890s, pushing the United States into a deep depression by 1893. Yet interest rates on farm loans stayed skyhigh at 30 to 40 percent. Angry debt-pressed farmers in the South and West organized into Farmers' Alliance clubs during the 1880s. In 1892, these organizations coalesced into a political movement, known as the Populist Party. By 1896, the Populists and their Republican allies controlled North Carolina's government and passed laws to help ordinary citizens—such as increased public school spending and a 6-percent interest rate cap on farm loans. (Mecklenburg Farmers Alliance, 1880s; courtesy of Helen Kinney.)

Leonidas Polk, born in Anson County, North Carolina, first tried education, then politics, to help farmers drowning in debt. In 1886, Polk began publishing *The Progressive Farmer*, a national newspaper that taught the latest farming techniques. He became the president of the National Farmers' Alliance, which lobbied state governments to create schools for farmers, including what are now North Carolina State University, North Carolina Agricultural and Technical University, and Clemson University. But education alone could not get farmers out of debt, so Polk helped create the Populist Party in 1892 to speak for farmers nationwide. The Populists welcomed both white and black voters. They became one of the most successful third parties in United States history. (Courtesy of the North Carolina Department of Cultural Services.)

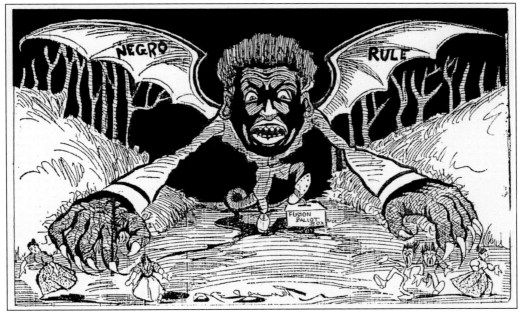

To stop the upstart Populists, old-line leaders in North Carolina organized "White Supremacy Campaign." They worked to get laws passed in North Carolina that sharply limited the right to vote, with the aim of ending what they called "the rule of Negroes and the lower classes of whites." (From the *News and Observer*, 1868.)

Township No. 3, Cabarrus County, N. C.

No. 1680 192___

RECEIVED OF McElrath, Odell

the following taxes for 1922:

TAX RATES PER $100		
County Schools $.39		
County Tax15		
Roads20		
Interest and Sinking Fund11		
Total Rate $.85		

1922

Poll Tax - - - - - $ 2.00

County { School, County Roads and Interest and Sinking Fund } $_____

Total - - - - - $ 2.00

Special School - - - $_____

Grand Total - - - $_____

Discount—Penalty - - $_____

Amount Paid - - - - $_____

Dog Tax - - - - - $_____

PAID

C. L. SPEARS, SHERIFF

BY

_____Sheriff,

Per_____D. S.

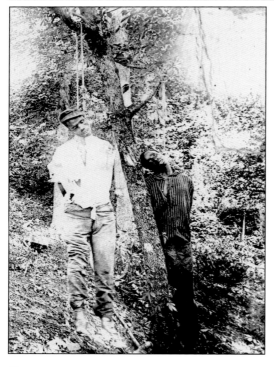

North Carolina's new constitution of 1900 instituted poll taxes—a way to keep poor whites and African Americans from voting. To vote citizens had to pay. The tax on this Cabarrus County receipt seems small today, but $2 was a lot to a poor farm family, especially when it had to be paid months in advance during spring, a time when cash was short. (Courtesy of the Levine Museum of the New South.)

Anti-Populist and anti-voting racial scare tactics included a sharp increase in lynching. African Americans accused of crimes—real or imagined—were publicly murdered without benefit of trial, such as these two men in Cabarrus County. Lynching reached an all-time high throughout the South during the 1890s. (Courtesy of the Charles Cannon Memorial Library, Concord Branch.)

Thomas Dixon, a Baptist minister born west of Charlotte near Shelby, helped lead the Disfranchisement Campaign that drove African Americans out of North Carolina politics in 1900. To justify disfranchisement, he wrote novels glorifying Reconstruction-era terrorism, including the national bestseller *The Clansman*. (Courtesy of Wake Forest University, Special Collections.)

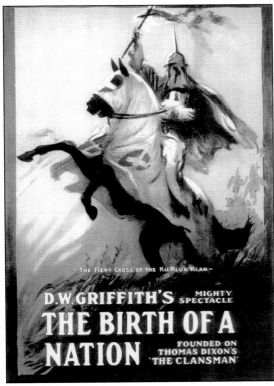

The Clansman became a hugely popular movie, *The Birth of a Nation* (1915), the world's first feature-length motion picture. Many viewers accepted its glorious depiction of the Klan as truth, including President Woodrow Wilson, who marveled, "It is like history writ with lighting. And my only regret is that is all so terribly true." (Courtesy of the Levine Museum of the New South.)

MARCH 8, 1914.

SOUTHERN RAILWAY

PREMIER CARRIER OF THE SOUTH

TIME TABLES OF PASSENGER TRAINS

E. H. COAPMAN,
VICE-PRESIDENT & GEN'L MANAGER.

S. H. HARDWICK,
PASSENGER TRAFFIC MANAGER.

H. F. CARY, GENERAL PASSENGER AGENT.

GENERAL OFFICES, WASHINGTON, D. C.

Railroad connections transformed Charlotte from just another backcountry town to a regionally important New South center. In 1852, local merchants and planters built the very first railroad into the Carolina Piedmont: the Charlotte & South Carolina Railroad. Rail lines continued to grow and, in 1894, the Southern Railway was formed from many smaller companies. Its mighty mainline extended from Washington, D.C., to New Orleans. Charlotte now sat astride this "Main Street of the South." (Courtesy of the Levine Museum of the New South.)

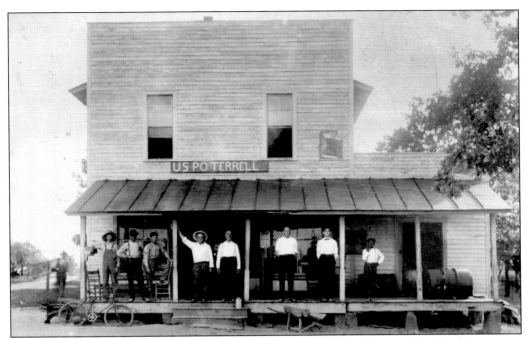

Merchants were at the heart of the New South economy—selling farm supplies, lending money, and buying cotton from farmers, then ginning and baling it before sending it by railroad to factories up north or through cotton brokers to Europe. An excellent example of a crossroads merchant is the Terrell Store, photographed in 1900, which still welcomes customers on Highway 150 in Catawba County. (Courtesy of the Catawba County Historical Association.)

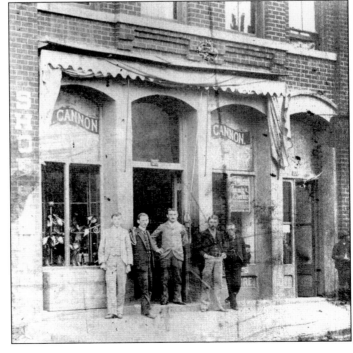

A successful small-town merchant could amass cash to start other businesses. James Cannon's family ran the Cannon and Fetzer Mercantile Store in Concord, seen here about 1885. Cannon turned the business into a textile mill empire in Concord and Kannapolis. (Courtesy of Paul Kearns.)

Farming in the Carolina Piedmont began to change in the 1920s. The boll weevil swept through, destroying cotton crops. Trucks and tractors cut the need for tenants. Many Carolinians left the land, moving to New South cities such as Charlotte, or heading up north. Today, less that one percent of southerners make their living from agriculture. (Courtesy of the Catawba County Historical Society.)

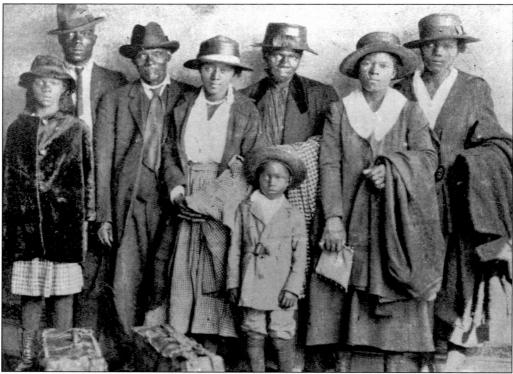

African Americans especially fled the South's double burden of poverty and disfranchisement; they "protested with their feet." Starting around 1900, more than 3 million black southerners left for northern cities—a process called "the Great Migration." Seen here are African Americans newly arrived in Chicago from the South, c. 1917. (From *The Negro in Chicago*, 1922.)

Three

BRING THE MILLS
TO THE COTTON
1880s–1930s

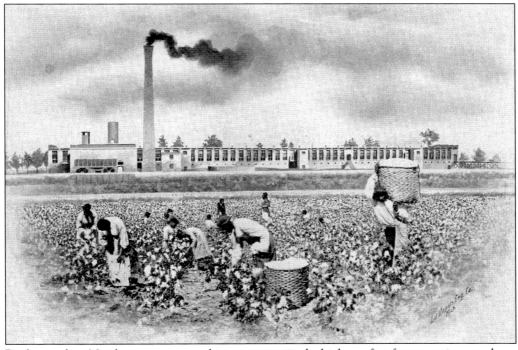

Realizing that Northerners were making comparatively high profits from turning southern cotton into cloth, New South leaders in the 1880s began calling for the South to build its own mills; "Bring the mills to the cotton," they cried. Small-town merchants began constructing cotton mills, and the Piedmont, long a region of farms, reinvented itself as a region of factories and changed the way thousands of people lived. The Atherton Mill, shown here, still stands on South Boulevard in Charlotte. (Courtesy of the Robinson-Spangler Carolina Room, PLCMC.)

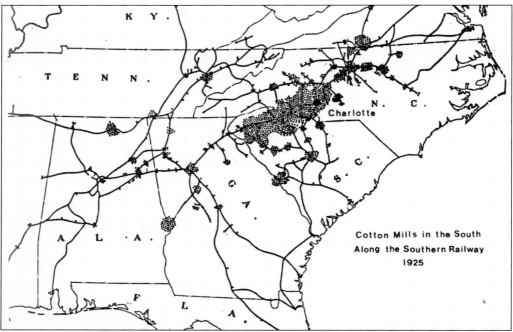

Most of the cotton mills in the southeastern United States clustered along the Southern Railway. Charlotte exploited this strategic advantage and, by the early 1900s, the city's textile tycoons happily reported, "half the looms in and spindles in the South are within one hundred miles of this city." In the 1920s, the South passed New England to become America's main textile producing region. (Adapted by William Huffman from Potwin, *Cotton Mill People*.)

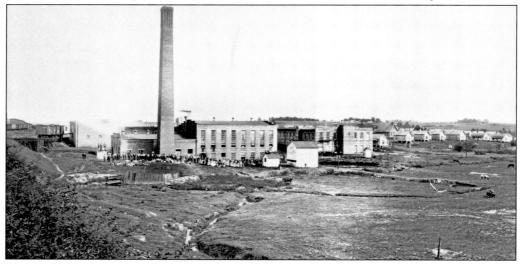

The Highland Park No. 1 mill opened in 1891 and still stands today on 16th Street just off North Tryon Street in Charlotte. The photograph shows many of the essential elements of a New South textile factory: the railroad to bring in baled cotton and move finished products out; the smokestack indicating a coal-burning boiler that powered machinery; workers' housing; a church; and the labor force of men, women, and children. There was even room for the workers to keep a small amount of livestock. (Courtesy of Levine Museum of the New South.)

No one did more than D.A. Tompkins to bring industry to the Carolinas. Born in South Carolina and educated as an engineer in New York, Tompkins arrived in Charlotte about 1883. He designed cotton mills, wrote books on cotton manufacturing and finance, and set up textile training programs at Clemson and North Carolina State Universities. He even published the *Charlotte Observer* to spread his vision of an urban, industrial New South. (Courtesy of the Robinson-Spangler Carolina Room, PLCMC.)

The D.A. Tompkins Company erected over 100 textile factories across the South and invented the technology to turn cotton seeds into cooking oil. (Courtesy of the Levine Museum of the New South.)

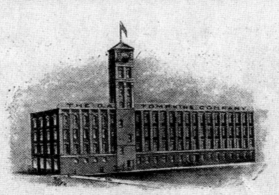

D. A. TOMPKINS CO.

MANUFACTURERS ENGINEERS CONTRACTORS
Dealers In MACHINERY

CHARLOTTE, North Carolina

We design and build complete

Cotton Mills

Cotton Oil Mills

Refineries

Fertilizer Works

Steam Power Plants

Electric Light and Power Plants

Fire Protection

Steam Heating

We Manufacture

Cotton Mill Machinery

Oil Mill Machinery

Tanks and Towers

Shafting

Hangers

Gears

Pulleys

Roller Gins

SUPPLIES

General Repairs

We rebore Corliss Engine Cylinders, or reconstruct Engines complete on their foundations.

39

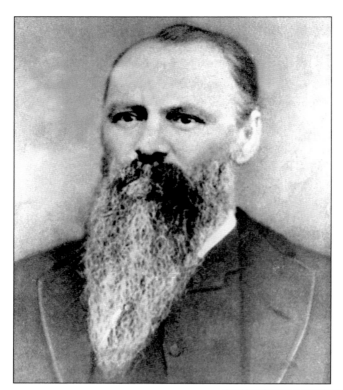

Robert Calvin Love's crossroads general store was the economic hub for farmers in Woodlawn (now Mt. Holly). By 1887, he was prosperous enough to make the step from merchant to industrialist, helping start Gastonia's first cotton mill, the Gaston Cotton Manufacturing Company. The Love family went on to build many other mills and R.C.G. Love's grandson Spencer Love founded Burlington Industries, which became the world's largest textile company in the 1930s. (Courtesy of James F. Love III.)

Like many Piedmont mill founders, Leroy Springs got his start as a storekeeper. Building on his family's wealth as plantation owners, he went into business as a merchant and banker in Lancaster, South Carolina. In 1892, Springs married Grace White, whose father had just built a cotton mill in the railroad village of Fort Mill. Springs took charge and added other factories across upstate South Carolina. (Courtesy of the William Elliott White Homestead.)

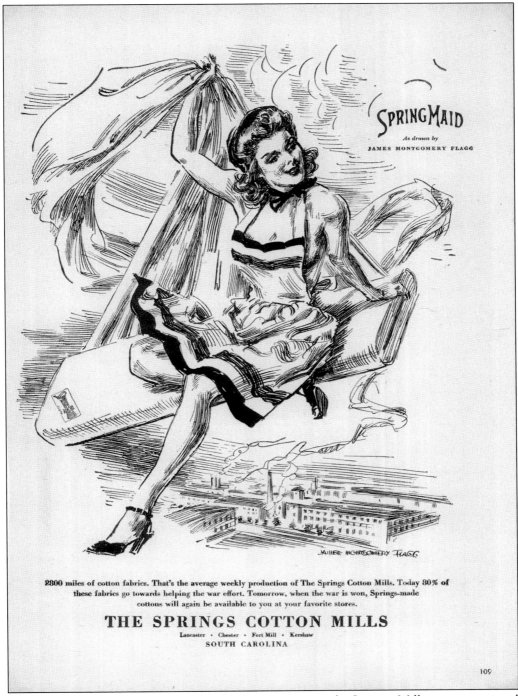

Leroy's son, marketing genius Elliott White Springs, made Springs Mills into a national powerhouse known for its Springmaid-brand sheets. This 1943 advertisement was drawn by noted artist James Montgomery Flagg and was part of a national campaign devised by Elliott Springs to launch the Springmaid brand. (Courtesy of the Levine Museum of the New South.)

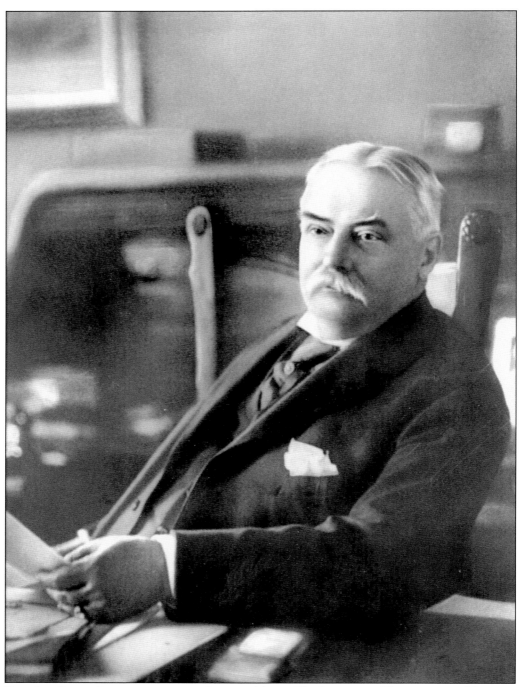

Farm-boy James Cannon went to work at age 14 in a Charlotte store. He soon opened his own store in nearby Concord and, in 1884, built the South's first towel factory there. Twelve years later, Cannon created Kannapolis, which became North Carolina's largest company-owned mill town. (Courtesy of the Charles Cannon Memorial Library, Kannapolis Branch.)

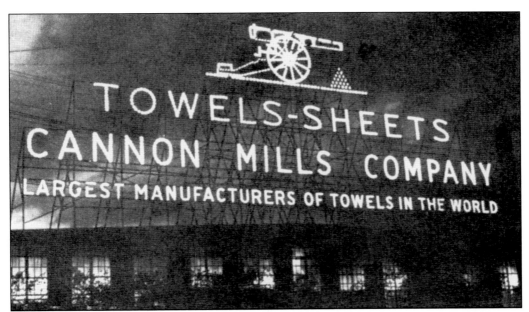

James's son Charles made Cannon Towels an international household name. In 1923, his workers invented machinery to sew brand name tags onto towels and began a series of ad campaigns that introduced consumers to the idea that towels could be stylish. By the 1940s, Cannon Mills produced half of all towels sold in America. (Courtesy of the Charles Cannon Memorial Library, Kannapolis Branch.)

In a cotton factory, air must be just the right temperature and humidity; otherwise, the yarn breaks. Engineer Stuart Cramer (left) in Charlotte and rival Willis Carrier working in nearby Belmont, North Carolina, competed to invent devices to supply constant temperature and humidity. (Courtesy of John Hilarides.)

Cramer filed patents in 1906 under the name "air conditioning," coining the term used worldwide today for temperature and humidity controls. Inventing air conditioning devices was just one of Cramer's successes. He sold textile machines throughout the South, engineered dozens of mills and villages, including North Charlotte, and founded the textile town of Cramerton near Gastonia. (Courtesy of the United States Patent and Trademark Office.)

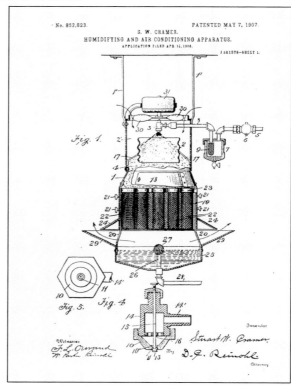

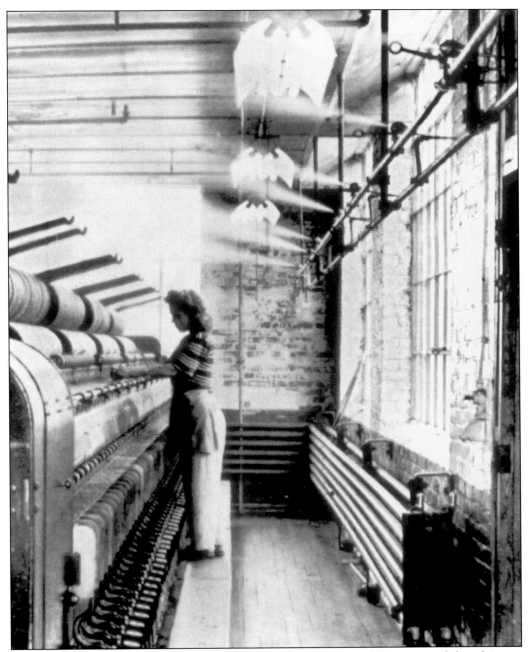

Ironically, the warm moist air produced by Cramer's system, good for cotton, did nothing to increase mill works' comfort. Parks-Cramer misting nozzles are visible in the top corner of this photo from Atherton Mill in Charlotte in the 1940s. (Courtesy of John Hilarides.)

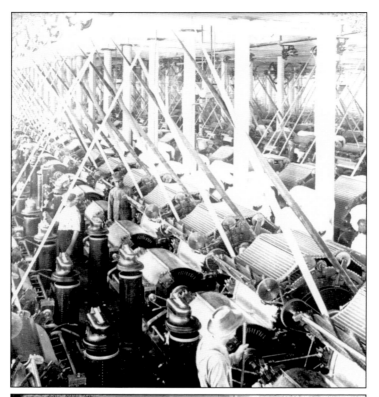

To turn cotton into cloth, the raw fiber was first fed into a carding machine, which used thousands of tiny wire spikes to comb the fibers straight. Cotton dust in carding rooms, such as this one at White Oaks Mill in Greensboro, was especially bad and the machines had to be stripped out every couple of hours. Because of exposure to airborne cotton dust, mill hands in this period often suffered from brown lung. (Above and left, courtesy of the National Museum of American History.)

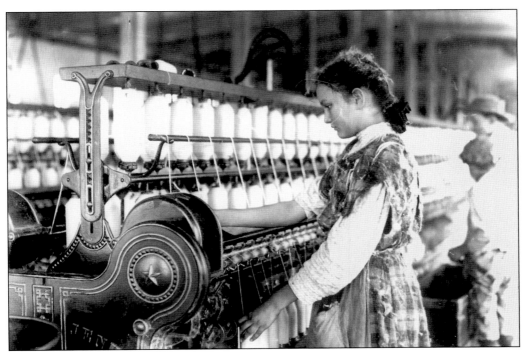

After carding and roving were complete, a series of machines gradually twisted the fibers together into long, strong strands. Final twisting was done on a spinning frame, like the one on which this Cherryville, North Carolina girl was working. The frame filled wooden bobbins with yarn (in a cotton mill, all thread was called "yarn"). (Above, photo by Lewis Hine; courtesy of the National Archives. Right courtesy of the National Museum of American History.)

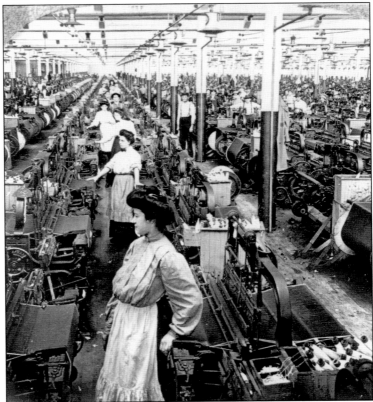

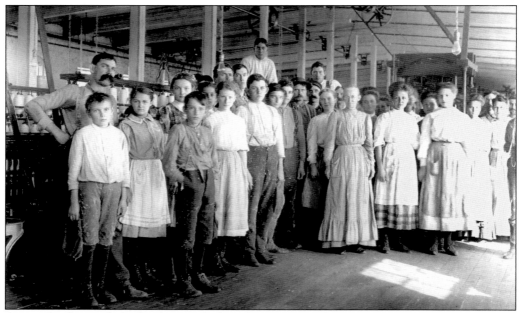

As on the farm, whole families worked in the cotton mill. Men took the heaviest and most physically demanding jobs—bale openers and carders—and the highest paying—loom fixers and overseers. Men and women worked at spinning and weaving. Throughout the 20th century, the Carolinas led the United States in percentage of women working outside the home. Children started in jobs such as sweeping or "doffing," removing spindles from fast-moving machines. (Photo by Lewis Hine; courtesy of the National Archives.)

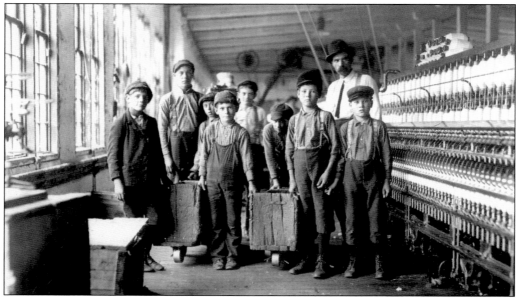

At first, it just seemed natural that youngsters should work in the mills. Back on the farm, everyone had worked. Children learned farming by laboring alongside their parents. But soon, people began to question whether factory work was good for children. (Photo by Lewis Hine; courtesy of the National Archives.)

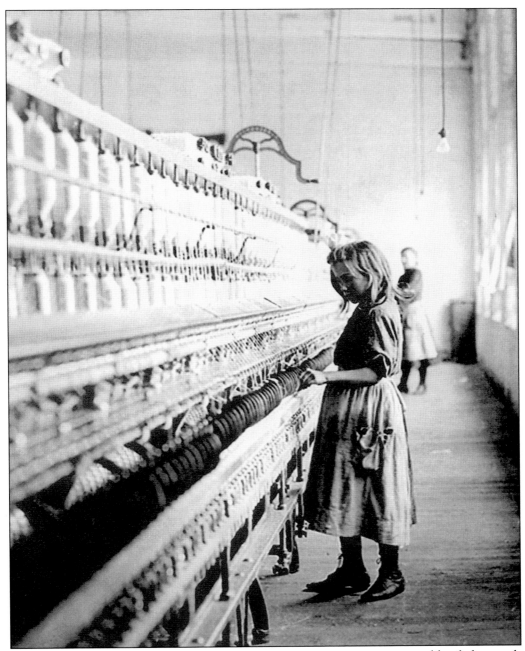

In the early part of the 20th century, youngsters as young as six or seven years old toiled as much as 12 hours a day, six days a week in the Piedmont's cotton mills. Mill owners—struggling to compete against New England—welcomed families who brought children into the mill. In 1900, over 25 percent of North Carolina textile workers were under the age of 16, compared to less than 7 percent in New England. (Photo by Lewis Hine; courtesy of the National Archives.)

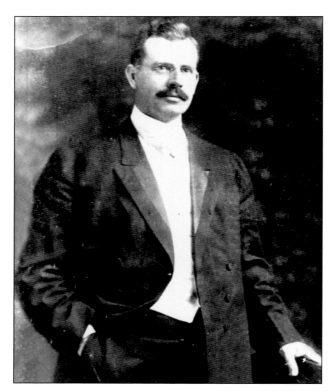

Charlotte Presbyterian minister Rev. A.J. McKelway helped win passage of America's first child labor law. He co-founded the National Child Labor Committee in 1904 and hired photographer Lewis Hine to document child labor conditions in the mills around Charlotte. In 1916, McKelway's writing and Hine's heart-touching photos convinced Congress to outlaw factory work for children under 16. However, the law was overturned two years later due to efforts by another Charlottean, David Clark. (Courtesy of Alexander J. McKelway V.)

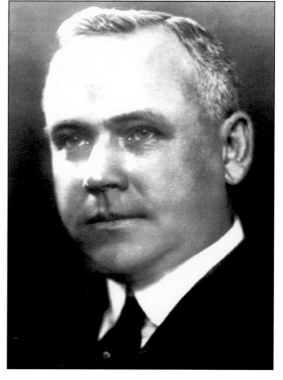

Southern Textile Bulletin publisher David Clark of Charlotte led the fight against United States child labor laws. Clark arranged for Charlotte mill worker Ronald Dagenhardt to file suit, charging that Congress had unconstitutionally deprived him of his right to have his 13- and 15-year-old sons employed. The Supreme Court ruled in favor of Clark and Dagenhardt in 1918. The United States did not outlaw child labor again until the 1938 Fair Labor Standards Act. (Courtesy of North Carolina State University, Special Collections.)

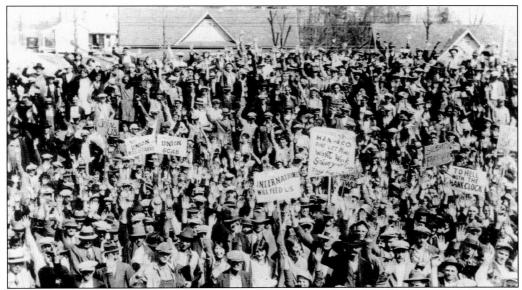

Making textiles for the world put the Carolina Piedmont at the mercy of world economic cycles. Textile prices slid during the 1920s, then dropped even further in the Great Depression of the 1930s. Mill owners cut pay and instituted a "stretch-out"—often halving wages while doubling each employee's workload. Carolina mill hands organized strikes in 1929 (seen here in Gastonia) and 1934. They stopped work, attempting to shut down mills until pay cuts and stretch-outs ended. (Courtesy of AP/Wideworld Photos.)

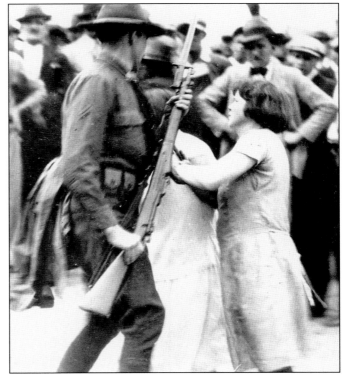

In 1929, workers in over 25 Carolina mills—in Charlotte, Gastonia, Pineville, Spartanburg, Marion, and Bessemer City—walked out in protest of wage cuts and increased workloads. At Gastonia's Loray Mill, the strikes turned violent, attracting worldwide attention. Facing powerful anti-union forces, the strikers lost. Here, the National Guard disperses strikers on orders from Gov. Max Gardner, himself a mill owner. (Courtesy of the Walter P. Reuther Library, Wayne State University.)

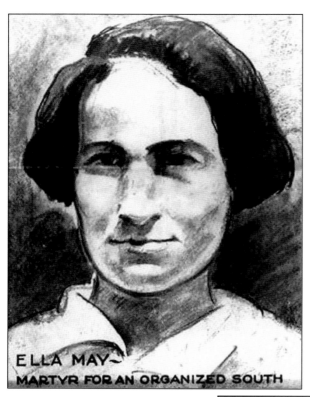

ELLA MAY~
MARTYR FOR AN ORGANIZED SOUTH

Abandoned by her husband, Ella May Wiggins found work in Bessemer City's American Mill for $9 per week. After four of her nine children died from poverty-related illnesses, she joined the Textile Workers Union. She became the union's most effective local organizer by singing ballads that touched listener's hearts, including her own "Mill Mother's Lament." She was shot to death on September 14, 1929, when armed men forced a truck filled with unionists off the road. Though the shooting occurred in broad daylight with dozens of witnesses, no one was ever brought to trial. (From the *Labor Defender*, October 1929.)

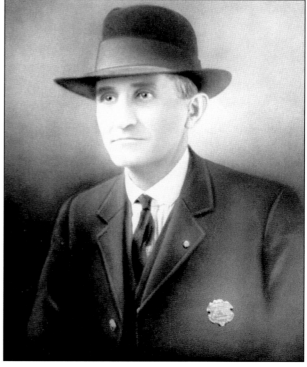

Making a late-night raid on union headquarters, Gastonia police chief Orville Aderholt was shot to death on June 7, 1929. Although evidence suggested that the chief was accidentally shot in the back by his own deputy, police charged 14 strikers with murder. A Charlotte jury found seven guilty and sentenced them with up to 20 years in prison. (Courtesy of the Gaston County Museum of Art and History.)

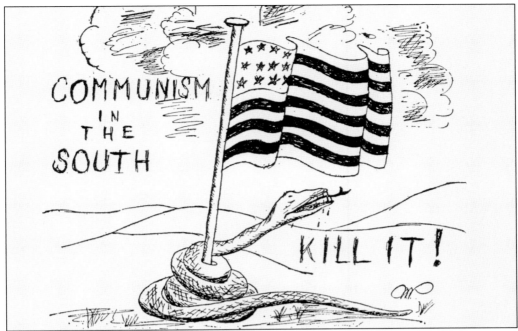

While most of the 1929 strikes were homegrown, the Communist Party helped organize and publicize the Gastonia walkout. Communists hoped all workers in the United States would revolt and overthrow capitalism. Mill hands in the South, already angry at mistreatment, seemed ripe for the picking. The strategy failed because many Southern workers resented "outsiders" who "stirred up trouble," as this cartoon drawn by a Loray employee suggests. (From the *Southern Textile Bulletin*, April 1929.)

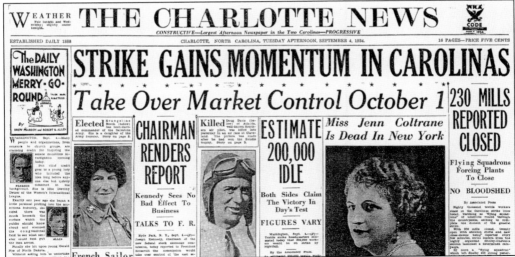

Workers remained angry at pay cuts and stretch-outs. Recently elected President Franklin Roosevelt promised government action as part of his 1933 New Deal, but nothing improved. On Labor Day, 1934, more than 300,000 workers throughout the South's cotton belt and as far north as New England walked out in the General Textile Strike, America's largest labor action ever.

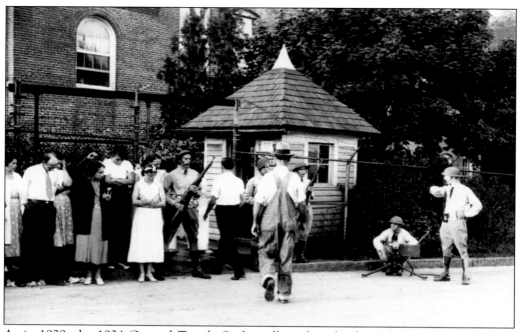

As in 1929, the 1934 General Textile Strike collapsed in the face of powerful mill owners, National Guard troops, and the reluctance of some workers to unionize. Here workers on strike pray silently as National Guardsmen help strike-breakers enter Concord, North Carolina's Gibson Mill on September 11, 1934. (Courtesy of UPI/Corpis-Bettmann.)

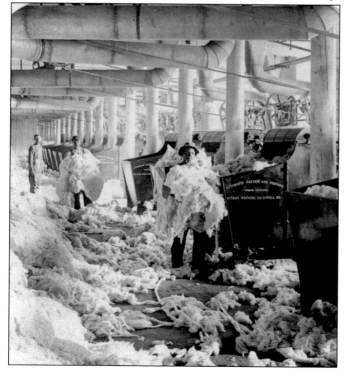

Textile manufacturers barred African Americans from most New South textile jobs. Black men usually worked as truck drivers, cotton bale handlers and openers (seen at left), or as janitors. Black women typically found no work other than as cleaning ladies. In 1914, South Carolina went as far as to make it unlawful for textile manufacturers "to allow or permit operatives, help and labor of different races to labor and work together within the same room." Until the 1960s, whites made up 96 percent of the Carolinas' textile workforce. (Courtesy of the National Museum of American History.)

Warren Coleman (center) was born a slave in 1849. Coleman rose to become a barber, then a storekeeper, then a real estate developer. In 1898, he built his own cotton mill to show that black people could be valuable workers in the South's textile factories. Coleman Manufacturing Company employed African Americans in all jobs. It won national attention but went out of business soon after Coleman's death in 1904. (Courtesy of the Library of Congress.)

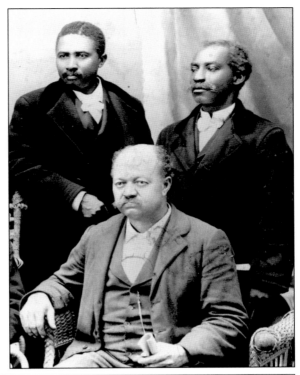

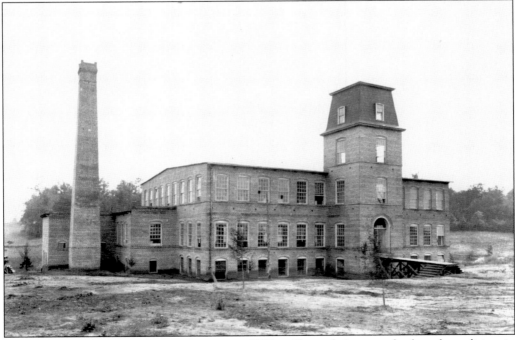

Coleman Manufacturing Company, seen in 1900, still stands in a much altered condition in Concord off the section of the U.S. 601 bypass named in Coleman's honor. (Courtesy of the Library of Congress.)

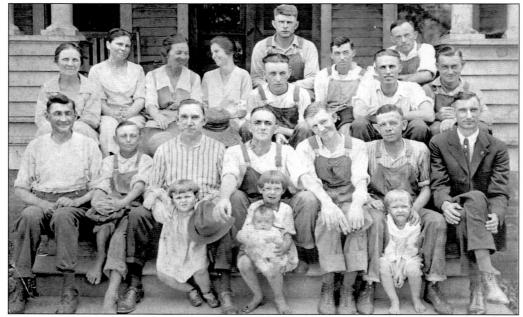

Textiles employed more people than any other industry in the Carolinas, such as these North Charlotte workers in the early 1920s. For thousands, the mill village was home. Villagers reinvented customs from the country for the new factory society. Traditions created to tie together isolated farmsteads—pitching in to help the sick, gathering to play music, visiting kin—became even more richly satisfying when neighbors were just a porch away. (Courtesy of Coy Shue.)

Farmers called mill jobs "public work." The phrase expressed the loss of independence that came with reliance on an employer. People who had worked according to the seasons now had to match rhythms on the machine. Many mill families, like the Bensons seen here in 1908, intended to stay in the mill only until they earned enough money to go back to farming. (Photo by Lewis Hine; courtesy of the Library of Congress.)

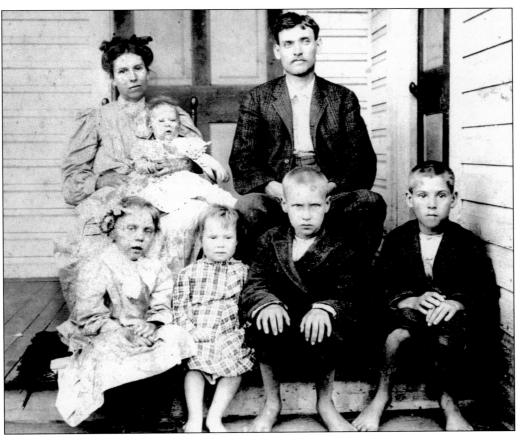

Farm families were pushed to the mills by failing crop prices and pulled by the attraction of cash wages paid each week. Such was the case H.P. Barrett, who moved his family from a farm near Spencer, North Carolina, to Charlotte's Belmont neighborhood to work in the Louise Cotton Mill. They are seen on the porch of their Pegram Street mill home in 1910. (Courtesy of John Brady.)

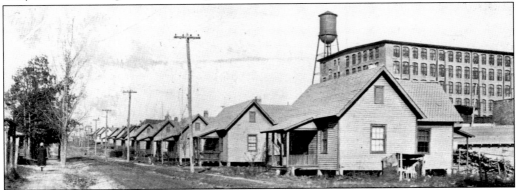

Carolina Mill owners located their factories away from towns and built villages for their workers next to each mill. Mill cottage porches became favorite places for workers to gather and visit. Nevertheless, owners had extra power over their employees because of the village; employees who disagreed with the boss risked not only losing their jobs but also their family homes. (From *Southern Textile Bulletin*.)

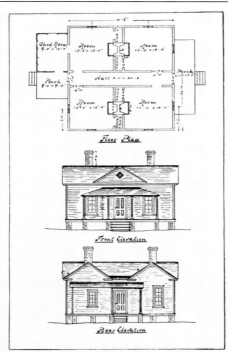

Fig. 36. Four-Room Gable House. Cost $400

D.A. Tompkins's mill cottage designs, published in his 1899 book *Cotton Mill Commercial Features*, were used in textile communities across the South.

In 1908, photographer Lewis Hine captured this image of Gastonia mill youngsters playing marbles. Most likely they are using "pea-dab" marbles made from hardened mud, popular among mill village children who could not afford glass marbles. (Courtesy of the Library of Congress.)

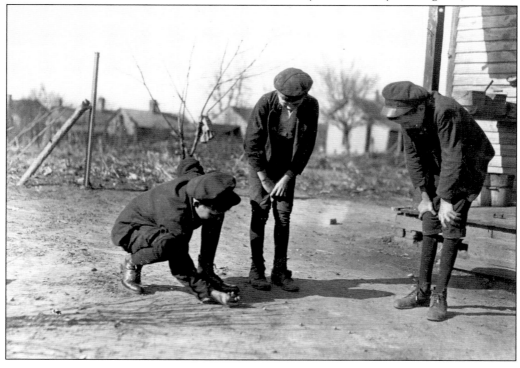

Kitty Miller worked as a spinner in Cramerton, North Carolina, and at the Eagle Mill in Belmont, North Carolina, from the age of 14 until she retired 44 years later. She played piano and guitar for friends in the mill village and at First Baptist Church and wrote a regular newspaper column called "Eagle Mill News." (Courtesy of Betty Hinson.)

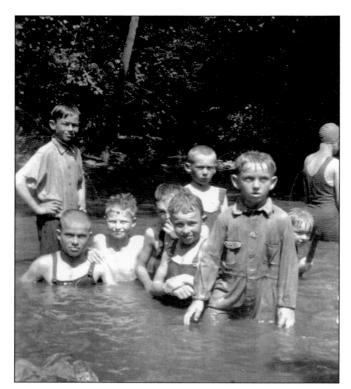

Kids from the North Charlotte mill village cool off at a local swimming hole, c. 1930. (Courtesy of John Brady.)

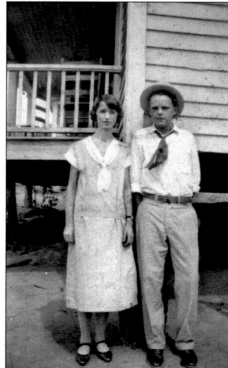

Courting couple Alma Britton and Arthur White are standing beside a mill cottage in the Clara–Dunn–Armstrong Mill's village in Gastonia. (Courtesy of Melinda Desmarais.)

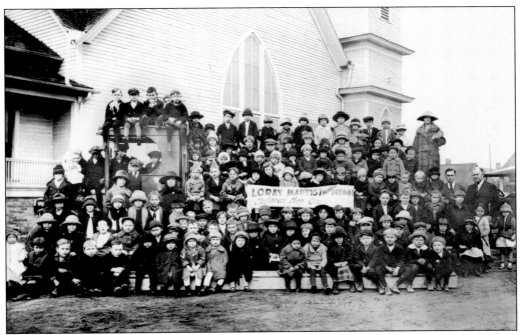

Textile companies often donated land and money to start churches in their mill villages; sometimes they even hired the clergy. Jesse Spencer, owner of mills in North Charlotte, provided land for North Charlotte Baptist Church and Spencer Memorial Methodist Church. Likewise, mill villages in Gastonia (above: Loray Baptist, 1925), Concord, Kannapolis, and many other Piedmont towns have churches paid for by mill owners. (Courtesy of the Gaston County Museum of Art and History.)

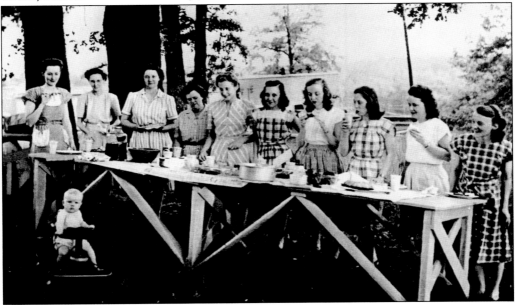

In many textile towns, the mill hosted a summer picnic for employees. (Courtesy of the Cooleemee Historical Society.)

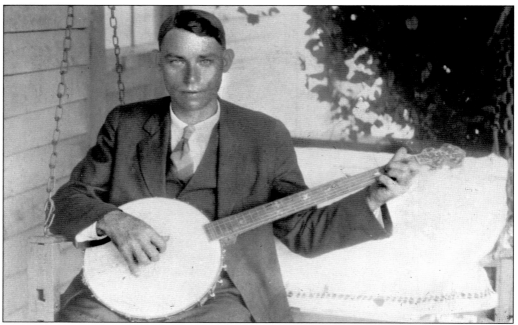

Old-time dance tunes born in the country were favorites in the mill village. On the farm, community dances happened mostly at harvest. But in the mill village, folks were together all the time and often had a few coins jingling in their pockets. Thus, with a built-in audience and real money to be made, a new brand of professional musician sprang up, such as Charlie Poole (above) a cotton mill worker from Spray, North Carolina, who recorded more than 80 songs for Columbia Records between 1925 and 1930. (Courtesy of Kinney Rorrer.)

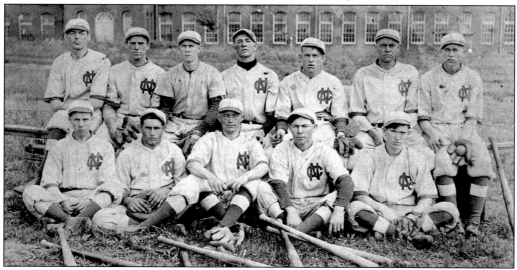

By the 1930s, a "Carolina League" made up of mill baseball teams played across the Piedmont in 20 cities from High Point to Shelby. The team from Charlotte's Highland Park Mill No. 3, seen here in 1923, was one of the best. Numerous mill players made it into the majors, most famously "Shoeless" Joe Jackson, who started sweeping floors at Greenville, South Carolina's Brandon Mill when he was 13 years old. (Courtesy of Coy Shue.)

Four

BUILDING CITIES
1900s–1930s

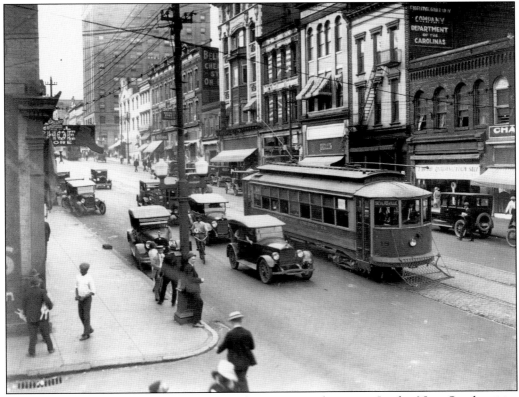

In the Old South, cities were rare, just a few ports on the coast. In the New South, cities blossomed everywhere along the railroads. During the 1920s, Charlotte passed the old port of Charleston as the largest city in the two Carolinas. Boosters ceaselessly called for new growth. By 1920, 25 percent of southerners lived in "urban places"—more than ever before, though still far below the United States average of 50 percent. This 1920s photo shows East Trade Street in Charlotte. (Courtesy of the Levine Museum of the New South.)

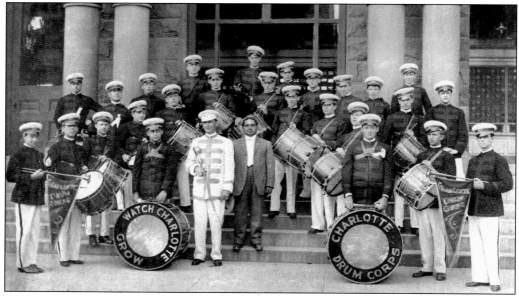

Boosterism was an essential part of the New South. Business leaders, still smarting from the loss of the Civil War and struggling against persistent poverty, organized the Charlotte Chamber of Commerce in 1877. They published "booster booklets" and advertised in magazines to attract more business to the area. Their motto, adopted in 1905, "Watch Charlotte Grow," is emblazoned on this parade drum of the Charlotte Drum Corps. (Courtesy of the Robinson-Spangler Carolina Room, PLCMC.)

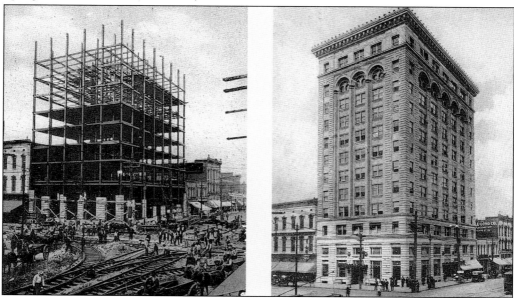

Constructed in 1908, the Realty Building was at 12 stories the tallest building in North Carolina and the first steel-framed skyscraper erected in the two Carolinas. It was originally home to Charlotte Realty and Trust Company and other businesses. Later called the Independence Building, the imposing structure stood in downtown Charlotte on the northwest corner of Trade and Tryon until it was imploded in September 1981. (Courtesy of Mary Boyer.)

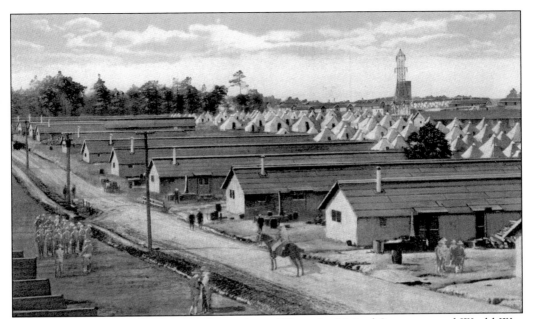

Boosters did not just talk, they got things done. When the United States entered World War I in 1917, the Charlotte chamber convinced the army to build the huge Camp Greene on the city's west side. In existence for only two years, it brought over 60,000 soldiers—and many thousands of dollars—to the city. (Courtesy of the Levine Museum of the New South.)

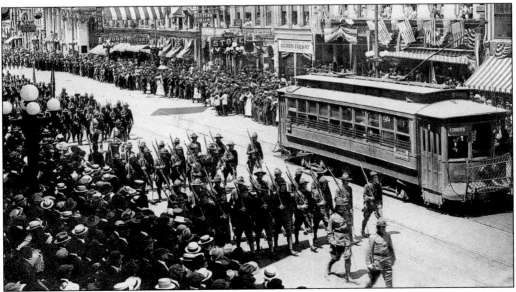

World War I soldiers are shown here marching down Tryon Street. (Courtesy of Kugler's Studio.)

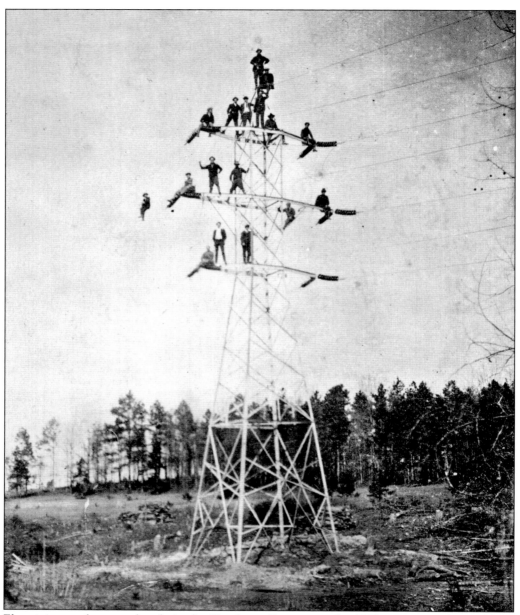

Electricity was harnessed early in the Carolinas. Starting in the 1880s, engineers learned how to use the Piedmont's rivers to electrify individual cotton mills. Next, they devised some of America's first long-distance power lines. By the 1910s, when this photo was taken, Carolina Piedmont cities were hooked into a power grid, one of America's earliest. (Courtesy of the Duke Energy Corporate Archives.)

The Southern Power Company was created in Charlotte in 1904 by engineer William States Lee (left) with money from tobacco tycoon James B. Duke (right) and Gill Wylie. The company's earliest customers were the Piedmont's textile mills. The Southern Public Utilities Company, a subsidiary of Southern Power, operated Charlotte's electric streetcar system. Southern Power became Duke Energy, one of the largest utility companies in the world. (Courtesy of the Duke Energy Corporate Archives.)

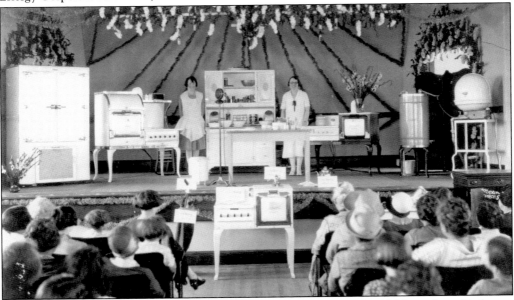

Southern Public Utilities Company staged events like this one in the 1930s to show Piedmont housewives the difference that electric appliances could make in their lives. Sold right from the electric bill payment centers in every Piedmont city, new appliances changed life at home. No longer would the ice wagon visit your house every few days to put a new block of ice in the "ice box." (Courtesy of the Duke Energy Corporate Archives.)

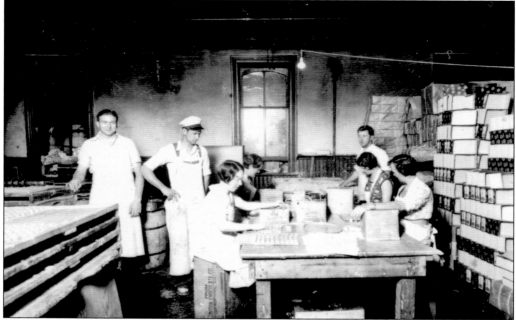

In 1913, Charlotte coffee broker Phillip L. Lance accidentally got stuck with a large shipment of peanuts. Rather than let them go to waste, he roasted the nuts and sold them on uptown street corners. In 1914, a soldier from Camp Greene shared a peanut brittle recipe with Lance, which became the basis of the company's "Peanut Bar." The business took off. Soon Lance's wife and daughter spread peanut butter on crackers, inventing the snack cracker, Lance's most famous packaged food. (Courtesy of the Robinson-Spangler Carolina Room, PLCMC.)

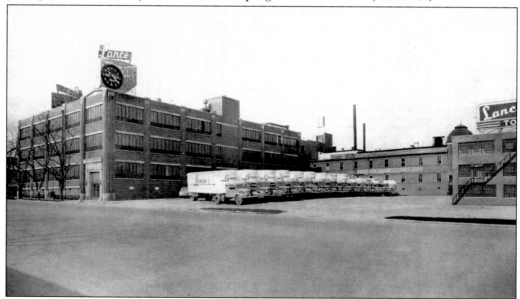

By 1926, Lance's company moved into this three-story building on South Boulevard (seen here in the 1940s). Today, the company is headquartered in nearby Pineville and is one of the South's biggest snack makers. (Courtesy of the Robinson-Spangler Carolina Room, PLCMC.)

At the age of 26, William Henry Belk opened a shop in Monroe, North Carolina. Soon he moved up the railroad to Charlotte, on East Trade Street near the cotton platform. Belk saw that the New South's growing cities made possible a new kind of store—the big "department store." And if many department stores bargained together, manufacturers would give the lowest prices. So Belk traveled the South forging partnerships with other merchants. Before long, more than 300 stores across the South stocked their shelves from the Charlotte warehouses of Belk Store Services. (Courtesy of the Belk, Inc. Archives.)

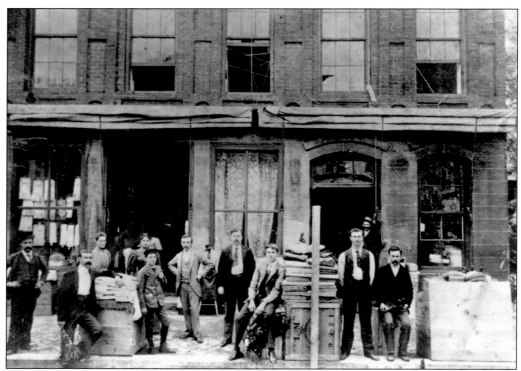

The original Belk Store began in 1888 in the railroad town of Monroe. Belk called it "The New York Racket." (Courtesy of the Belk, Inc. Archives.)

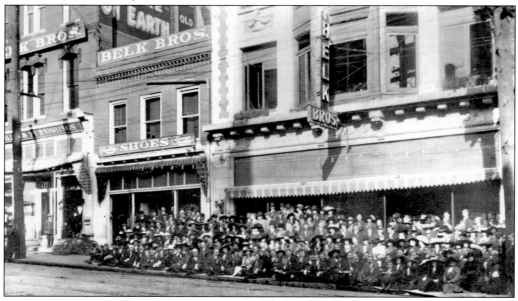

The small building with the "shoes" sign was Belk's first Charlotte shop, which started in 1885. Here employees gather outside the greatly expanded store on East Trade Street, c. 1915. The store was demolished in the 1980s to make way for the Founder's Hall complex. (Courtesy of the Belk, Inc. Archives.)

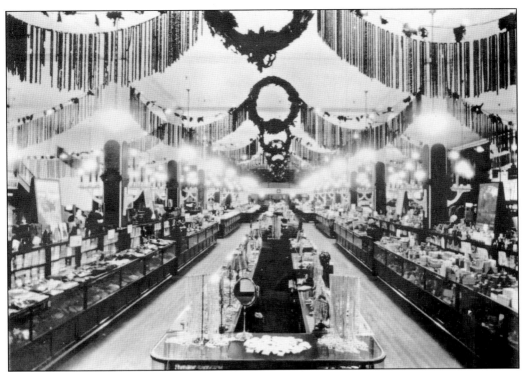

Most New South cities had more than one department store. Efird's and Ivey's (seen above decorated for Christmas in the 1930s), both headquartered in Charlotte, were regional chains that competed with Belk. Efird's merged with Belk in the 1950s and Ivey's merged with Dillard's in the 1980s. (Courtesy of UNC Charlotte, Special Collections.)

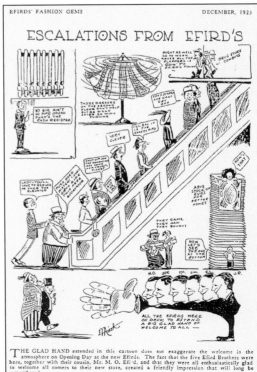

In the early 1920s, people came from all over to ride Efird's escalator—the first in the region. This cartoon illustrates people's amazement and in some cases fear of not being able to get off. (Courtesy of the Belk, Inc. Archives.)

CHARLOTTE N. C. "City of Beautiful Churches"

HAWTHORNE LANE METHODIST CHURCH

MYERS PARK METHODIST CHURCH

FIRST METHODIST CHURCH

DILWORTH METHODIST CHURCH

© CURT TEICH & CO., INC.

6B-H2103

CHARLOTTE CONGREGATIONS IN 1940

	white	black
Baptist	16	25
Presbyterian	21	5
Holiness	5	13
Methodist	13	2
AME Zion		11
Lutheran	5	2
Episcopal	6	1
United House of Prayer		5
African Methodist Episcopal		4
Roman Catholic		2
Apostolic		1
Congregational		1
Greek Orthodox		1
Jewish		1
Moravian Episcopal		1
Nazarene		1
Reformed		1
Seventh Day Adventist		1
Nondenominational	17	4

Charlotte population in 1940: 100,899

The South has had a distinctive religious culture. Protestant Christians predominated, especially evangelicals, who felt called by God to convert their neighbors. In this part of the Piedmont, most people attended either an evangelical church—Baptist, Methodist, Holiness, AME Zion, United House of Prayer—or they attended a Presbyterian or Lutheran church, the faiths of the Piedmont's Scotch-Irish and German settlers. The region attracted few immigrants during the early New South era, thus few Catholics or Jews.

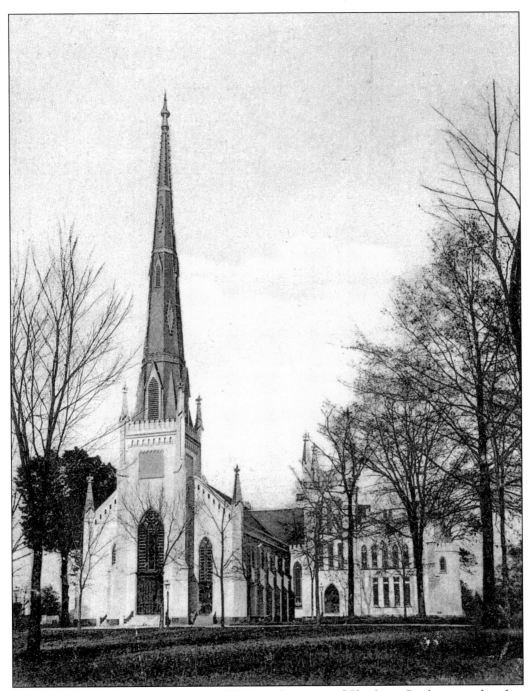

First Presbyterian Church occupies a full block at the center of Charlotte. Presbyterian churches dominate the downtowns of many nearby communities as well, a lasting legacy of the region's first European arrivals. Local Presbyterians today are fond of saying that Charlotte's success as a business city owes much to the hardworking attitude instilled by those founding Presbyterians. (Courtesy of the Robinson-Spangler Carolina Room, PLCMC.)

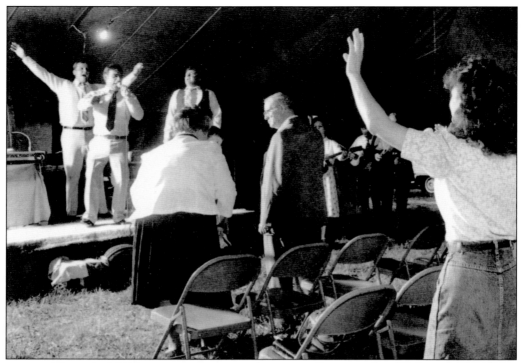

A wave on Pentecostal or "Holiness" revivals swept the United States around 1900, catching fire especially among working-class Southerners. Emotionally charged worship moved believers not only to be "born again in Christ," but also to be open to additional spiritual gifts, such as speaking in tongues. (Tent revival, 1988; courtesy of the *Charlotte Observer*.)

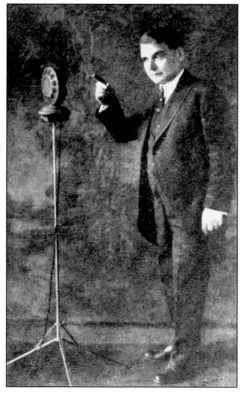

Luther Little, the pastor of Charlotte's First Baptist Church, was the first man in the United States to broadcast an evening sermon over the radio. (From the WBT Radiologue.)

Charlotte's Billy Graham grew up on a dairy farm near today's Park Road Shopping Center and attended the Chalmers Associated Reformed Presbyterian Church in the Dilworth neighborhood. At the 1935 Evangelical Crusade of Mordecai Ham, in a temporary wooden Tabernacle on Central Avenue, 17-year-old Billy experienced the religious awakening that led him to preach. (Courtesy of the Billy Graham Evangelical Association.)

Graham became a Baptist minister. By the 1950s, he was America's best-known religious leader. He excelled at using modern techniques such as radio, records, and television to bring his southern message of evangelism to millions worldwide. (Courtesy of the Billy Graham Evangelical Association.)

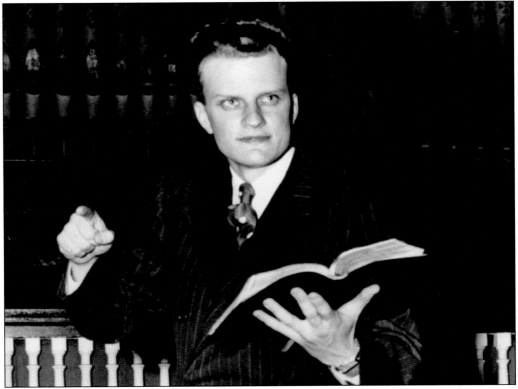

Charles Manuel Grace came from Africa's Cape Verde Islands. On June 26, 1926, he launched a tent revival in Charlotte. Planned for a week, it lasted all summer. "Sweet Daddy" Grace's mass baptism of 643 converts in Lakewood Park made news as far away as New York. Grace founded the United House of Prayer for All People in Charlotte, and although he later moved the organization to Washington, D.C., he returned every year to the birthplace of his movement. As of 2000, there were 132 churches throughout the United States.

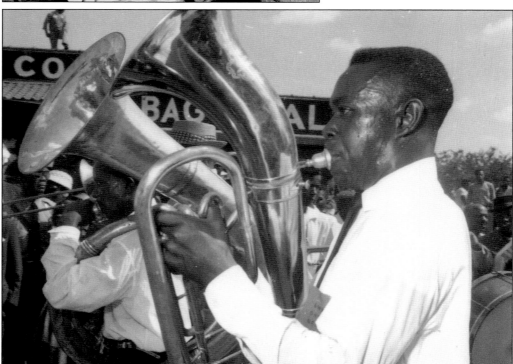

"Shout bands" made up of trombones, tubas, and drums comprise a distinctive tradition within the United House of Prayer for All People, as shown in this 1958 photo of the annual fall convocation parade. (Courtesy of the Robinson-Spangler Carolina Room, PLCMC.)

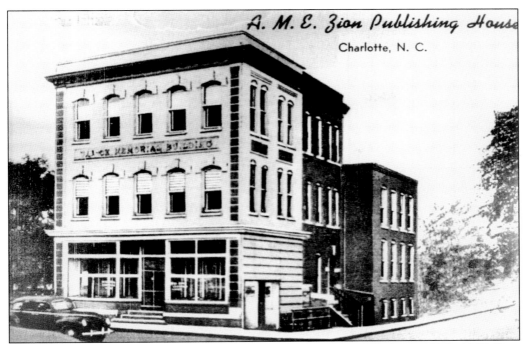

The African Methodist Episcopal Zion Church began in New York in 1796. AME Zion missionaries arrived in New Bern, North Carolina, during the Civil War to minister to black Union soldiers. They found great success winning converts in the Carolinas and set up Livingstone College in Salisbury, North Carolina, in 1879. The AME Zion Publishing House opened in Charlotte in 1894 and printed all of the denomination's Bibles and hymn books, as well as the influential *Star of Zion* newspaper. Today, Charlotte is the world headquarters of the faith, which has over a million members. (Courtesy of AME Zion Historical Society.)

Charlotte's black Episcopal church, Saint Michael and All Angels, worked with white Episcopalian Jane Wilkes to build Good Samaritan in 1888—North Carolina's first private hospital for African Americans. It was just one example of the role churches played as centers of the African-American community in the New South. Good Sam was demolished during construction of Ericsson Stadium. (Courtesy of the Levine Museum of the New South.)

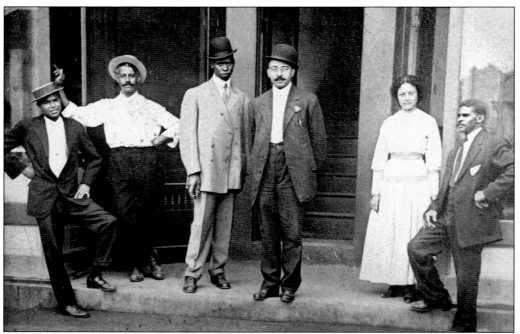

A "Black Main Street" developed in most New South cities, near Main Street but set apart. In Charlotte, many African-American businesses clustered along East Second and spilled onto South Brevard and McDowell Streets. This was "Brooklyn," the largest of Charlotte's half-dozen black neighborhoods. (Courtesy of the Robinson-Spangler Carolina Room, PLCMC.)

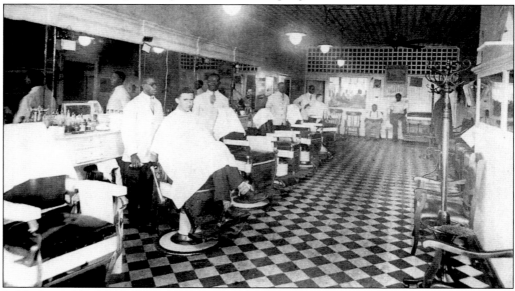

In black neighborhoods, barbershops became lively gathering places. Men and boys visited, told jokes, shared news . . . and even got their hair cut. In white neighborhoods, barbershops were segregated but ironically were also usually owned and run by African Americans, such as this uptown shop. White barbers were rare in the South into the 20th century. (Courtesy of the Robinson-Spangler Carolina Room, PLCMC.)

Thad Tate reigned as Charlotte's top barber from the 1890s into the 1940s and was an important African-American leader. White businessmen and government officials flocked to his handsome shop in the Central Hotel at Trade and Tryon Streets, giving him useful connections. Among his accomplishments was the creation of the South's first public library for African Americans. (Courtesy of Ray Booton.)

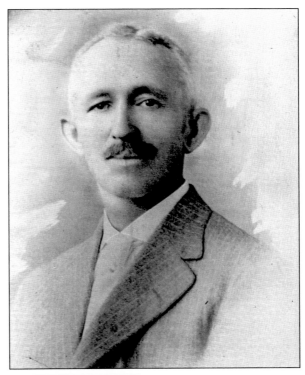

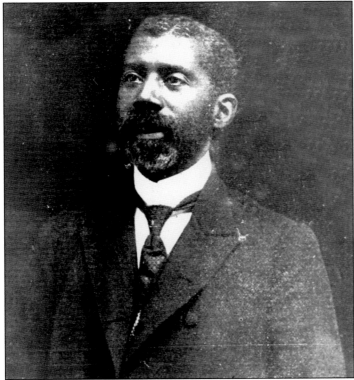

J.T. Williams arrived in Charlotte in 1882 to teach public school. He became one of North Carolina's first three licensed black physicians, opened the Queen City Pharmacy, and helped build an office building for black doctors and lawyers that still stands on South Brevard Street. Williams caught the eye of President William McKinley, who in 1898 appointed him U.S. Consul to Sierra Leone in west Africa. Today, Charlotte's J.T. Williams Middle School is named in his honor. (Courtesy of the Robinson-Spangler Carolina Room, PLCMC.)

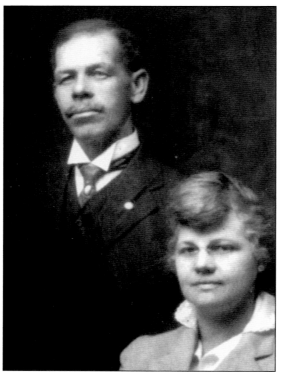

George Davis (left) came to Charlotte from Wilmington to attend what is now Johnson C. Smith University. He attained an advanced degree from Howard University and, in 1885, returned as JCSU's first African-American professor. He married Marie Gaston (right), a longtime schoolteacher and principal in Charlotte public schools. Today, Davis Hall at JCSU and Marie G. Davis School in Charlotte are named for these dedicated educators. (Courtesy of Diane McLaughline and Celeste Hicks.)

Upon retirement, Dr. George Davis became the North Carolina fund-raiser for Rosenwald Schools, a program started by Sears and Roebuck executive Julius Rosenwald, which offered matching grants to build schools for black students. However, half the money had to be raised by black citizens and white government. Thanks to Davis's tireless effort, North Carolina built 813 Rosenwald Schools—the most of any state. (Courtesy of the North Carolina Department of Cultural Resources.)

A doctor's daughter raised near Cornelius, North Carolina, Annie Alexander went off to Women's Medical College in Philadelphia, graduating at the top of her class. In 1885, she won her license to practice medicine as the first female licensed physician in the South. (Courtesy of UNC Charlotte, Special Collections.)

People scoffed when Dr. Alexander opened her office in Charlotte in 1887. She earned just $2 her first year. But she soon gained acclaim, serving at both St. Peter's Hospital and Presbyterian Hospital, and winning election as president of the Mecklenburg Medical Association. (Courtesy of the *Charlotte Observer*.)

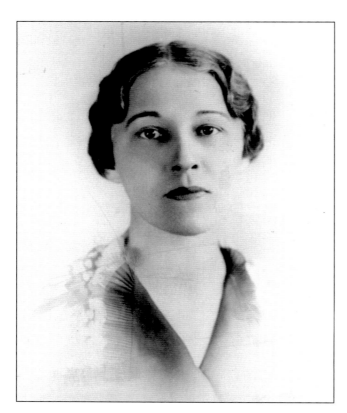

Charlottean Gladys Tillett was a longtime champion of women's rights. She organized support across North Carolina for the 19th Amendment, which gave women the right to vote in 1920. She started the North Carolina League of Women Voters, still a major force in politics today. She served as vice chairperson of the National Democratic Party from 1940 to 1950, and was named by President John F. Kennedy as United States representative to the United Nations Status of Women Commission. (Courtesy of North Carolina Department of Cultural Resources.)

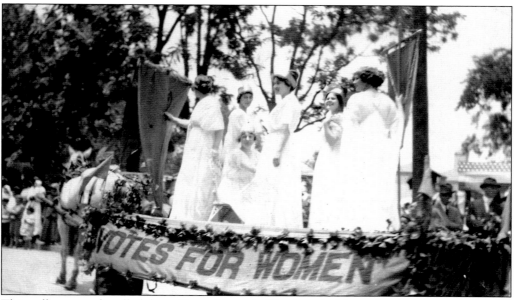

This suffrage parade rolled down Tryon Street in Charlotte in November 1914.

W.J. Cash wrote *The Mind of the South*, one of the most influential books to come out of North Carolina. Born in Gaffney, South Carolina, Cash grew up around Shelby, North Carolina, and graduated from Wake Forest College. He joined the *Charlotte News*, reporting on unions organizing in textile mills and other issues the business elite chose to ignore. *The Mind of the South* (1941) grappled with the Old South's legacies to the New South—individualism, religiosity, racism—and poked fun at boosterism. (Courtesy of the *Charlotte Observer*.)

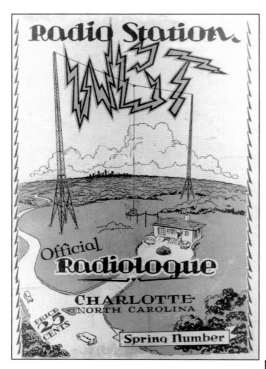

In 1922, WBT became the first radio station to go on the air in the Carolinas. In 1933, it won permission to broadcast at 50,000 watts, the national maximum. WBT covered both Carolinas during the day and at night had a "clear channel"; no other station along the eastern seaboard shared its spot on the dial, so WBT reached from Florida to New England. (Courtesy of the Robinson-Spangler Carolina Room, PLCMC.)

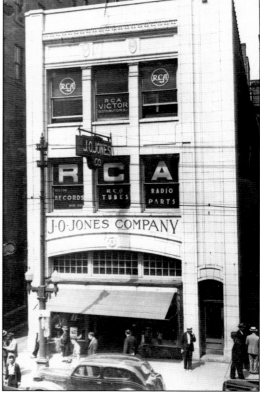

Because of WBT's clear channel, musicians flocked to Charlotte to play live on the radio. RCA Victor and Decca recorded hundreds of musicians at studios in RCA's regional office on South Tryon Street (right), in the Hotel Charlotte on West Trade Street, and in the Hotel Jackson in downtown Rock Hill, South Carolina. Charlotte's reign as a country music capital ended in the 1940s, thanks to Nashville's WSM radio, which had a clear channel signal covering the whole United States. Its "Grand Ole Opry" drew the talent and the record companies to Tennessee.

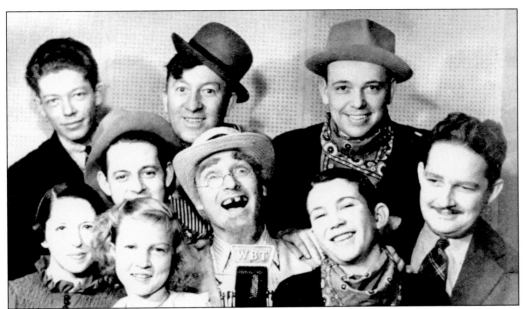

Throughout the heyday of live radio, the Briarhoppers were the "house band" at WBT. Announcer Charles Crutchfield formed the group to play the old-time fiddle tunes, hymns, and heart songs that Carolina listeners had grown up with. In the mid-1940s, the Briarhoppers broadcast weekly coast-to-coast from WBT on the CBS shows *Carolina Hayride* and *Carolina Calling*. Most Briarhoppers had careers of the own, most notably singer Fred Kirby, banjo player Shannon Grayson, multi-instrumentalist Arthur Smith, and the duo of Whitey and Hogan.

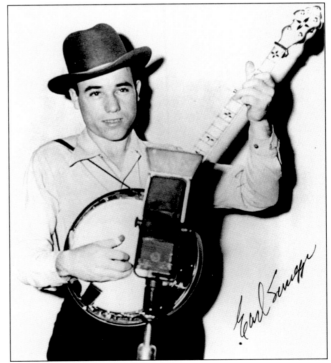

Earl Scruggs revolutionized banjo playing. Growing up as a farm boy and textile millhand near Shelby, North Carolina, he mastered Carolina banjo traditions. He then pushed the music to a new level with his "three-finger roll"—the hard-driving picking technique that defines bluegrass today. Scruggs and partner Lester Flatt had several hits to their credit, including "Foggy Mountain Breakdown" and the theme for TV's *The Beverly Hillbillies*.

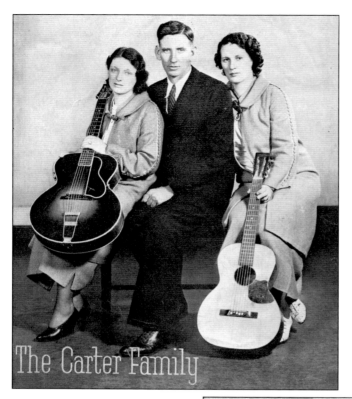

The Carter Family

The Carter Family came to Charlotte for several stints on powerful WBT radio, recording here for RCA Victor in 1931 and Decca in 1938. Sara, A.P., and Maybelle Carter are considered the founding family of recorded country music. Growing up in the Virginia mountains, the Carters learned hundreds of traditional songs. Their Charlotte records included *You Are My Flower, Let the Church Roll On,* and *My Old Cottage Home.*

One of the hottest brother teams in country music, Bill and Charlie Monroe made their first records at a Charlotte RCA session on February 17, 1936. In two years—between live radio and shows in Charlotte, Greenville, and Raleigh—they cut 60 songs, including "Nine Pound Hammer" and "Roll in My Sweet Baby's Arms." In 1930, Bill formed his own group—the Blue Grass Boys, named after his native Kentucky. With Bill's hot mandolin and "high lonesome" voice and the hard-driving banjo playing of North Carolinian Earl Scruggs, the group created the musical style called "bluegrass."

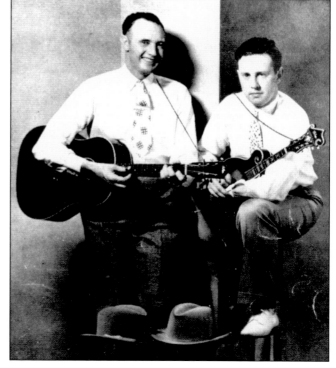

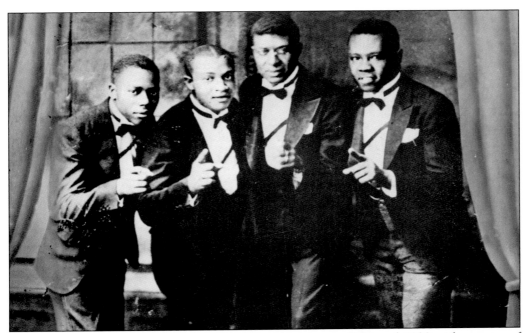

The Golden Gate Quartet burst onto the national scene in 1937 and 1938 with a series of records made in Charlotte and Rock Hill. They reinvented traditional *a cappella* gospel singing using rhythms from jazz and adding spoken "narrative." The Gates moved to New York, starred in their own weekly NBC and CBS radio shows, and sang at President Franklin Roosevelt's inauguration. In the 1950s, they emigrated to Paris.

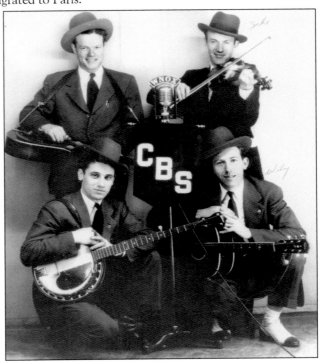

Fiddler/mandolinist Zeke Morris (upper right) came down from his native North Carolina mountains to play music in the Piedmont's mill villages. He joined the popular J.E. and Wade Mainer (lower left) of Concord, singing on their top-selling 1935 record, "Maple on the Hill." Zeke later form a duo with his guitar-playing brother Wiley (lower right.) They played on WBT for BC Headache Powders and recorded four sessions between 1939 and 1945 in Charlotte and Rock Hill. Their song "Salty Dog Blues" is now a bluegrass standard.

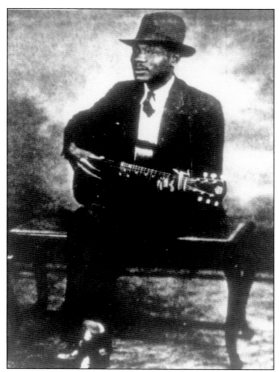

"Blind Boy" Fuller was born in Wadesboro, North Carolina. Blind at an early age, he became a familiar figure on the streets of Carolina cities during the 1930s, playing guitar for tips. Fuller found his way to Durham, North Carolina, and eventually to New York City, where he recorded songs in the ragtime-influenced "Piedmont Blues" style.

Arthur Smith grew up around the cotton mills of Kershaw County, South Carolina, where his father was a loom fixer and led the mill's brass band. Arthur took up trumpet, inspired by jazzman Louis Armstrong, but switched to guitar to win a spot on WPSA Spartanburg. In 1943, he moved to WBT Charlotte. When WBT Television signed on, Smith hosted a country music variety show syndicated on more than 100 stations into the 1970s. Smith is best known for writing "Dueling Banjos."

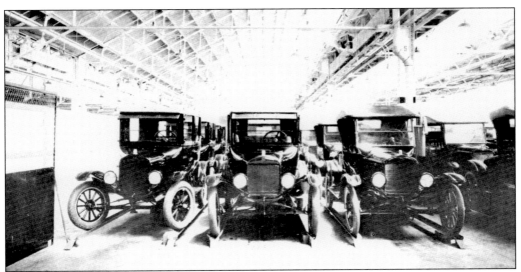

In 1925, the Ford Motor Company opened a gigantic automobile assembly plan on Charlotte's Statesville Avenue. The facility, the third built by Ford in Charlotte, assembled cars from components shipped from Detroit by railroad. The plant built 130,000 Model Ts and almost 100,000 Model As for distribution in the Southeast. The Stock Market Crash of October 1929 and subsequent Great Depression took their toll on the automobile industry. As Southerners' purchasing power declined, so did production at the Statesville Avenue Plant, which eventually ceased in 1932. (Courtesy of the Levine Museum of the New South.)

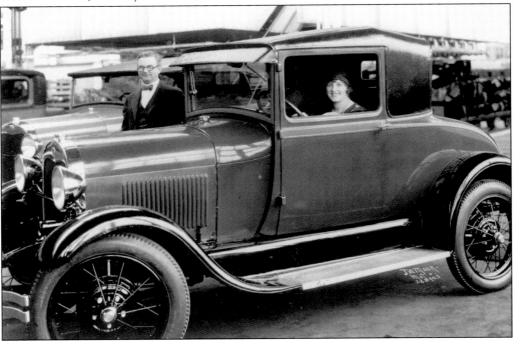

Mayor Marion Redd and his wife Bess watch as the first Model A Fords roll off the Charlotte assembly line. Bess is grinning behind the wheel because she had a driver's license—the mayor did not! (Courtesy of UNC Charlotte, Special Collections.)

Though railroads connected Charlotte with the South and the nation, it was still hard to get from the countryside into town. Vehicles sank deep in mud. In the 1890s, D.A. Tompkins pushed Mecklenburg County to build state-of-the-art "macadam" roads of close-packed gravel, which helped Charlotte grow faster than other Carolina cities. (Courtesy of the *Charlotte Observer*.)

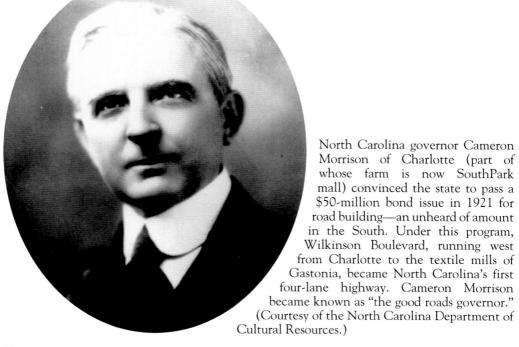

North Carolina governor Cameron Morrison of Charlotte (part of whose farm is now SouthPark mall) convinced the state to pass a $50-million bond issue in 1921 for road building—an unheard of amount in the South. Under this program, Wilkinson Boulevard, running west from Charlotte to the textile mills of Gastonia, became North Carolina's first four-lane highway. Cameron Morrison became known as "the good roads governor." (Courtesy of the North Carolina Department of Cultural Resources.)

Five

THE GREATEST NATION
1930s–1950s

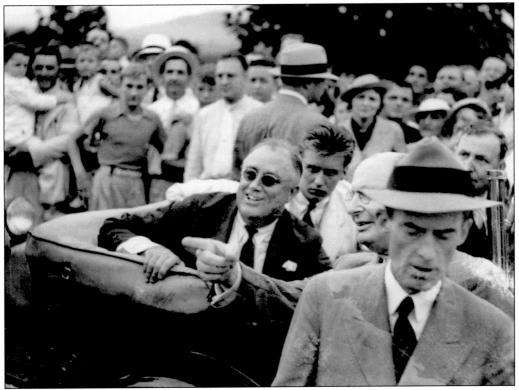

In the 1930s, President Franklin D. Roosevelt called southern poverty the nation's "number one economic problem." To address that poverty and to fight the nationwide Great Depression, Roosevelt (seen here in Charlotte in 1936) poured federal dollars into building projects all over America. This investment stepped up as the nation entered World War II and continued during the Cold War. New military bases, schools, hospitals, and highways helped remake the Carolina Piedmont. (Courtesy of Tom Franklin.)

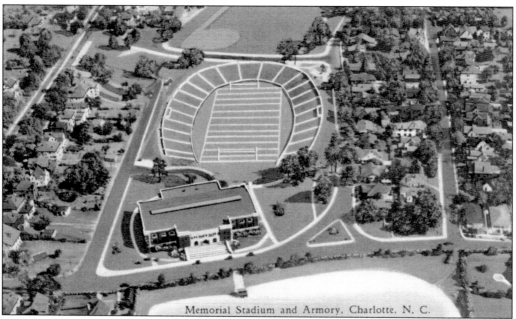

Memorial Stadium and Armory, Charlotte, N. C.

New Deal workers completed Memorial Stadium in September 1936, just in time to host President Roosevelt. The president delivered a stirring speech entitled "Green Pastures," in which he proclaimed that the nation would not prosper as long as the working people, especially the South's cotton farmers, could not make ends meet. Memorial Stadium was Charlotte's largest outdoor sporting complex until the 1990s and has hosted numerous college and high school football games over the years—the most well known is the annual Shriners' Bowl. (Courtesy of the Levine Museum of the New South.)

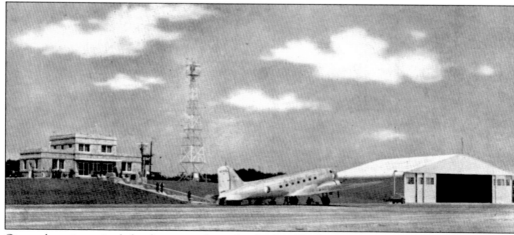

Once the city raised funds to purchase land, the Works Progress Administration created Charlotte's Municipal Airport. Between 1936 and 1937, WPA workers built three runways, a terminal building, a radio beacon tower, and a single hangar. Six flights took off daily from the airport in its first year of operation. In 1940, the city officially dedicated the facility as Douglas Municipal in honor of the Mayor Ben Douglas, who spearheaded the movement to build the airport. Today the original hangar is the Carolinas Aviation Museum. (Courtesy of the Levine Museum of the New South.)

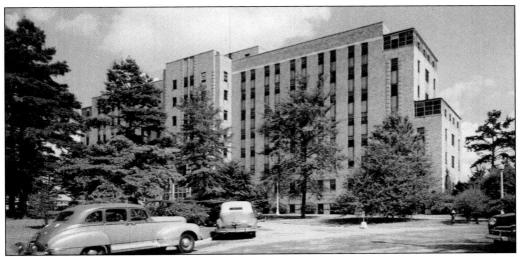

Federal money was also used to build Charlotte Memorial Hospital. Originally four stories tall with 300 beds, it was erected between 1938 and 1940 on land purchased by the board of St. Peter's Hospital. The hospital was instrumental in dealing with the 1948 polio epidemic that swept through the Carolinas. The site, seen here in the 1950s, has expanded several times over the years and now serves the community as Carolinas Medical Center. (Courtesy of the Levine Museum of the New South.)

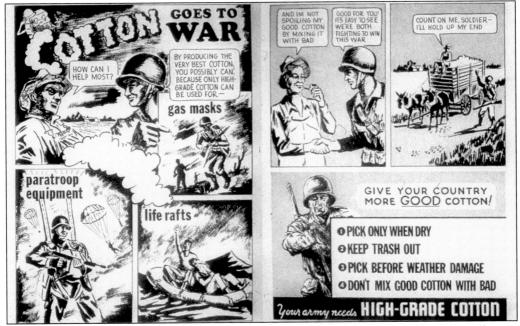

Carolina cotton goods were extremely important in the United States war effort. According to the War Department, the military needed over 12 billion yards of cotton cloth per year for items such as uniforms, parachute cords, tents, gas masks—about 40 individual items used to equip a soldier. This cartoon was part of a campaign undertaken to urge Piedmont cotton farmers and textile mills to boost production as high as possible to fight the Axis. (Courtesy of the National Archives.)

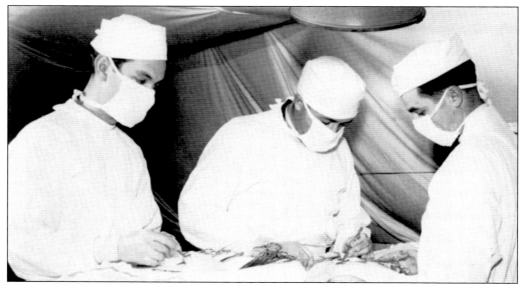

The 38th EVAC was an army medical unit comprised of doctors, dentists, and nurses from Charlotte hospitals (chiefly Charlotte Memorial.) During World War II, the unit supported frontline aid stations and Mobile Army Surgical Hospitals (MASH), treated disease, and transferred patients to general hospitals. Between March 1942 and July 1945, the unit saw service in North Africa and Italy, aiding American and Allied wounded prisoners of war and natives who became trapped in a war zone. Here Charlotte surgeon Capt. Duncan Calder Jr. operates on a patient. (Photograph by Margaret Bourke-White; courtesy of UNC Charlotte, Special Collections.)

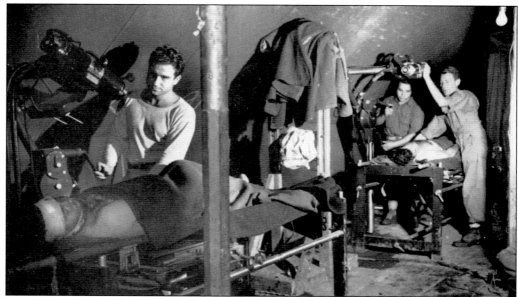

X-ray technicians work to evaluate injuries on newly arrived wounded. These machines have racks to hold the wounded soldiers' litters, allowing medical personnel to make X-rays without unnecessarily moving their patients. (Photograph by Margaret Bourke-White; courtesy of UNC Charlotte, Special Collections.)

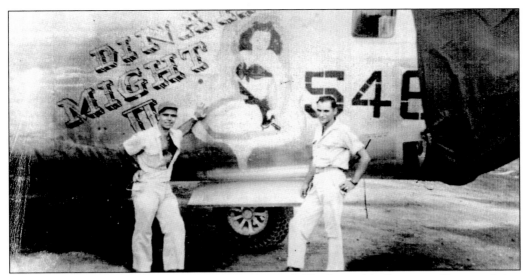

In January 1941, the Army Air Corps constructed Charlotte Air Base, a military training installation built to the south of Douglas Municipal Airport, adjoining its runways. The military acquired additional land for the project and lengthened and widened the runways. They built a huge hangar-repair facility, a hospital, reservoir, shops, barracks, and over 90 other structures—an addition estimated at $6 million. When the Japanese bombed Pearl Harbor, the base was renamed Morris Field. After the war, the facility was incorporated into Douglas Municipal. (Courtesy of the Carolinas Aviation Commission.)

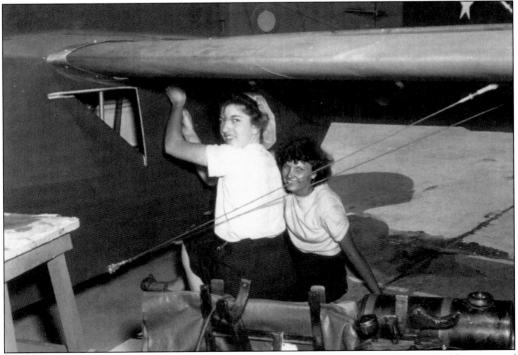

Here, two female mechanics repair a plane at Morris Field during World War II. (Courtesy of the Carolinas Aviation Commission.)

In May 1941, the U.S. War Department bought the old Ford Motor Company plant on Statesville Avenue (center building). They began to convert the facility for use as a depot for the Army Quarter Master Corps, including construction of five new warehouses. During World War II, the one million-square-foot facility stored and distributed "everything from toothpicks to battle gear" to U.S. Army posts in the two Carolinas and Virginia and when needed overseas. From the end of the war to January 1949, the QMC Depot was used to repatriate the war dead. (Courtesy of the Levine Museum of the New South.)

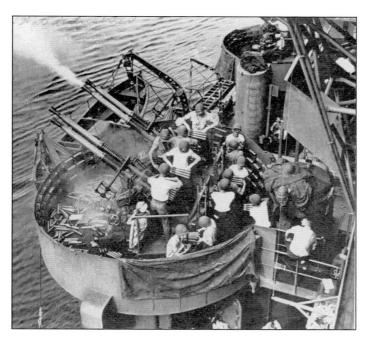

During the war, the U.S. Rubber Company produced 75 mm shells (seen in action here) for the U.S. Navy. The facility, which covered more than 2,000 acres on York Road, was known as the "shell plant" to its 10,000 employees—most of whom were women. The work was extremely dangerous, but there were no accidents at the plant, which at peak-levels manufactured as much as 213,143 rounds in 24 hours. Today, the remains of the facility are part of Arrowwood Industrial Park. (Courtesy of the Robinson-Spangler Carolina Room, PLCMC.)

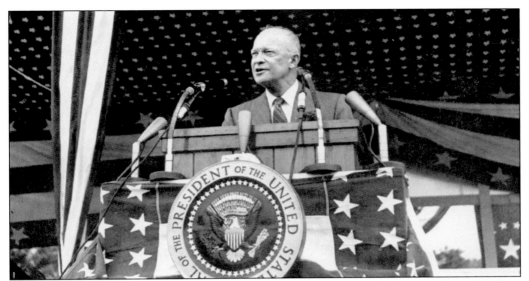

On May 20, 1954, President Dwight Eisenhower spoke to a crowd of more than 60,000 at Freedom Park. The event, depicted here on a souvenir program, was one of the grandest of the annual celebrations that honored the Mecklenburg Declaration of Independence. Earlier guests of honor had included Woodrow Wilson (1916), Howard Taft (1909), and Jefferson Davis (1864). The last large celebration took place in 1975. (Courtesy of the Levine Museum of the New South.)

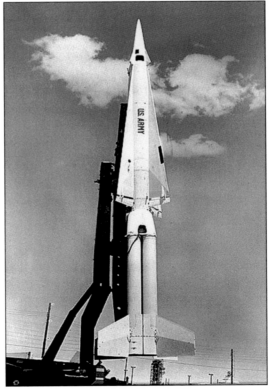

From 1956 to 1957, the Douglas Aircraft Company produced guided missiles for the military's Nike Program in the old Quartermaster Depot on Statesville Avenue. These missiles were the primary air defense system for the United States and many of her allies during the tense years of the Cold War. The early Nike Ajax was produced in both Charlotte and Santa Monica, California. The later and more important Nike Hercules missile (right) was produced solely in Charlotte, which was also the location for research and development on this and other Douglas weapons programs. (Courtesy of the Boeing Archives.)

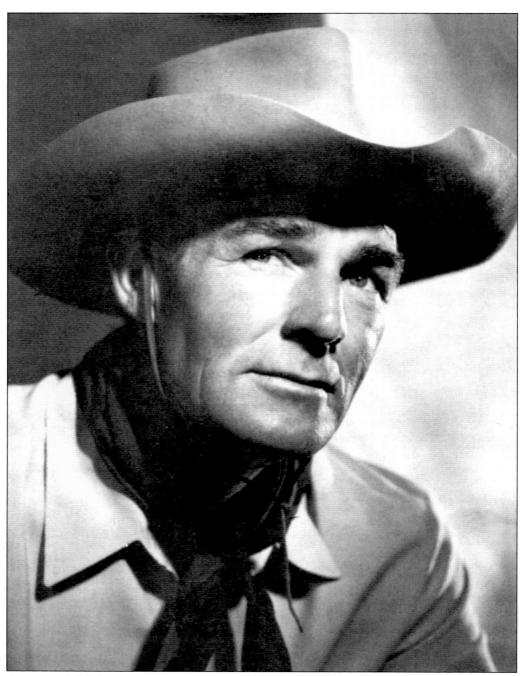

Actor Randolph Scott personified the nation's Cold War–era values on screen, as shown here in this 1950s postcard. He grew up in Charlotte's Fourth Ward, son of a prosperous businessman, and studied textile engineering at UNC Chapel Hill. In the 1930s, he began landing small acting parts, and during the 1940s and 1950s, he emerged as a top box-office draw. Scott became famous for cowboy roles in the type of films where the good guys wore white hats and always came out on top. (Courtesy of the collection of Ryan Sumner.)

Six

WE SHALL OVERCOME
1940s–1970s

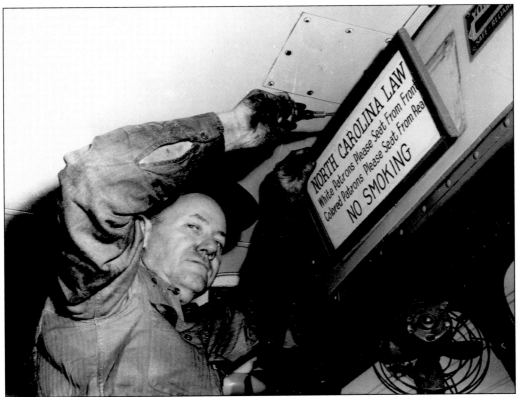

"Jim Crow" refers to the laws and customs that kept African Americans segregated from whites. Around 1900, southern states rewrote their constitutions to bar most blacks from voting. Once African Americans lost the vote, new laws were passed that forced blacks to sit at the back of buses and drink from separate water fountains. Black schools got much less money than white ones. African Americans were forbidden to live in many white neighborhoods. (Courtesy of Jack Mobes.)

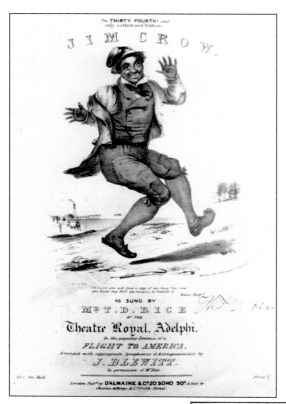

Jim Crow was originally a character from a minstrel song that made fun of black people. Sheet music, such as this 1855 example, helped spread the Jim Crow minstrel image. (Courtesy of the Valentine Museum.)

During the Great Depression, the government created "Residential Security Maps" like this one of Charlotte to guide lenders in making home loans. Intended to help banks, the system had the effect of hurting black neighborhoods. This map indicates that the white neighborhoods of Myers Park, Eastover, and parts of Dilworth, Elizabeth, Wesley Heights, and Plaza-Midwood are good lending risks. African-American neighborhoods (even middle-class ones) were automatically marked in red—the worst rating. Once "red-lined," it became very difficult for residents to get mortgage loans and become homeowners. (Courtesy of the National Archives.)

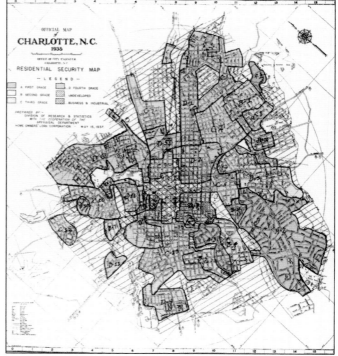

STATE OF NORTH CAROLINA

MECKLENBURG_____COUNTY.

Printed and For Sale by Kale-Lawing Co., Charlotte, N. C.

This Deed,

Made this_____30th_____day of

_____August_____, A. D. 19**2**1 by and between_____Leroy Parker_____

of the County of____Mecklenburg_____and State of____North Carolina____

part**y**____of the first part, and____J. N. Parker and wife, Jennie Parker,_____

of the County of_____Mecklenburg_____and State of____North Carolina_____

part **ies**____of the second part:

WITNESSETH, that the said party_____of the first part, in consideration of____ONE HUNDRED ($100.00)

DOLLARS and other good and valuable considerations_____

to **him**____paid by the part **ies**____of the second part, the receipt of which is hereby acknowledged,

ha **s**____bargained and sold, and by these presents do **es**____grant, bargain, sell and convey unto the

said **parties of the second part**_____and

their____heirs, all__that certain lot_____

_____of land, situate, lying and being in

Charlotte____Township,____Mecklenburg_____County, State of

North Carolina, and more particularly described as follows:

Being within the corporate limits of the City of Charlotte as now extended, and being lot No. 7 as shown and designated on the map of the property of the Mutual Trust Company, which said map is recorded in the office of the Register of Deeds for Mecklenburg County aforesaid in Book 230, page 76; said lot fronting 50 feet on Polk Ave., and extending back with that width 158 feet and 9 inches to an alley, all of which will appear by reference to said map. Being a part of the lands conveyed to the Mutual Trust Company by the Suburban Realty Company by deed registered in the Register of Deeds Office for Mecklenburg County in Book 254, page 333, to which reference is hereby made.

This conveyance is made upon condition that said lot shall be used for residential purposes only; that no house shall be erected thereon at a cost of less than $1500.00; and that same shall never be owned or occupied by any person of the negro race.

The right to use the alley above referred to and other alleys and streets shown on said map is hereby granted to the party of the second part, his heirs and assigns, in common with the owners of other lots shown on said map.

Being the same lot of land conveyed ty Z. Vance Veno and wife to Leroy Parker by deed recorded in Book 412, page 523, of the Mecklenburg County Registry.

Racially restrictive deed covenants played a major role in contributing to residential segregation. The one written into this Charlotte deed forbade African Americans from being able to own the property. Such clauses made sure that blacks and whites lived in separate neighborhoods. Clauses like this are now unconstitutional. (Courtesy of Sonny L. Sain.)

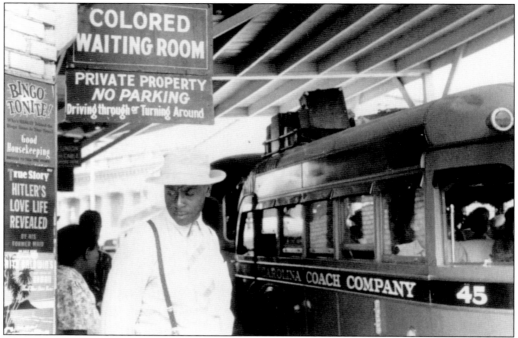

This segregated bus station in Durham, North Carolina, was photographed by Jack Delano. (Courtesy of the Library of Congress.)

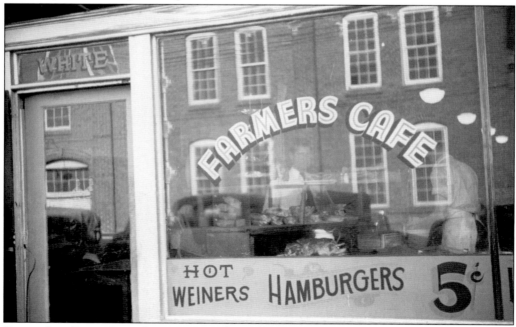

During Jim Crow, the only restaurants that fully served African Americans were part of the black business district. If a white establishment served blacks at all, they often had to use a separate, side entrance and take their food to go. (Photo by Marion Post Wolcott; courtesy of the Library of Congress.)

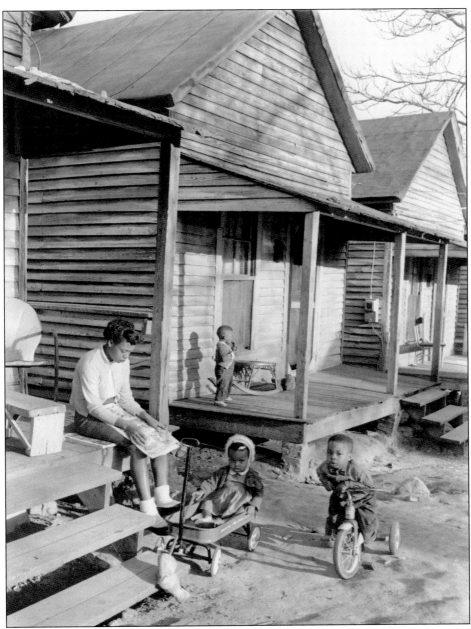

Jim Crow laws and customs blocked the economic advancement of many African Americans—which, in turn, hindered the economic growth of the South. Bank of America CEO Hugh McColl, who grew up in Bennettsville, South Carolina, in the Jim Crow era, points to the Civil Rights Movement as a beginning of the current "Sunbelt" boom: "It was not until the 1960s that we threw off the yoke of segregation, a yoke we had spent tremendous resources to create and maintain. In one stroke, we made possible a southern future where the talents, creativity and energy of all our people would be set free, to the great benefit of all." Above, Jim Crow housing in Charlotte's Brooklyn section is depicted from the early 1960s. (Courtesy of the Robinson-Spangler Carolina Room, PLCMC.)

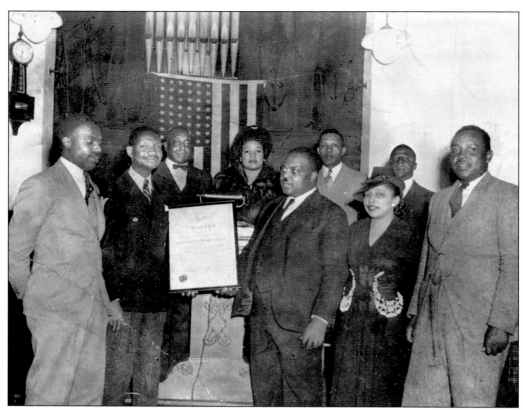

Civil Rights efforts began long before the 1960s. Local African-American leaders lobbied politicians, registered voters, filed lawsuits, and planned protests. Here Kelly Alexander Sr. (above, left) receives the charter for the Charlotte Chapter of the NAACP in 1940. (Courtesy of UNC Charlotte, Special Collections.)

When Dovey Johnson tried to volunteer for World War II, the military recruiter in her hometown of Charlotte would not let her sign up because she was an African American. She had to go to Richmond to enlist in the Women's Army Auxiliary Corps, becoming one of its first officers. After the war, Johnson became a lawyer and, in 1953, filed suit on behalf of Sarah Keys, a Korean War veteran jailed for refusing to sit in the back of a bus on her way home. *Keys v. Carolina Coach Company* resulted in the Interstate Commerce Commission's 1956 decision to outlaw segregation on interstate buses. (Courtesy of the Women in Military Service for America Memorial Foundation, Inc.)

After fighting to overthrow Hitler's vision of a world ruled by an "Aryan master race," Gerson Stroud returned to Charlotte where he was a second-class citizen. "It felt like a complete and utter letdown," he said. Stroud participated in early Civil Rights protests, and during the 1960s and 1970s, he helped usher in school desegregation as principal of York Road and West Charlotte High Schools. (Courtesy of the Robinson-Spangler Carolina Room, PLCMC.)

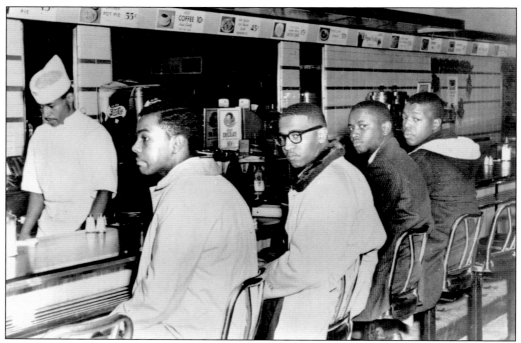

The Sit-In Movement began in Greensboro, North Carolina, on February 1, 1960, when four well-dressed black college students sat down at a whites-only lunch counter and politely asked to be served. It took over five months of persistence before lunch counters began serving African American customers in Greensboro. In the meantime, sit-ins spread throughout the South. (Courtesy of Jack Mobes.)

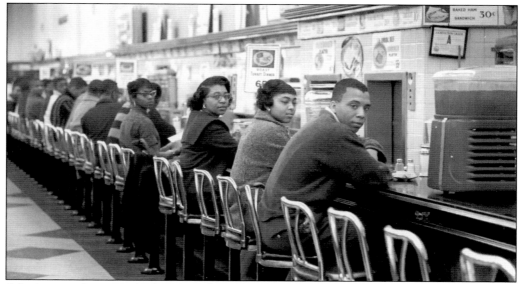

A little more than a week after sit-ins began in Greensboro, students in Charlotte picked up the idea. J. Charles Jones, age 22, rallied over 200 fellow Johnson C. Smith University students and marched uptown to "sit-in" at Woolworth's and all of Charlotte's other store lunch counters on February 9, 1960. (Courtesy of the Robinson-Spangler Carolina Room, PLCMC.)

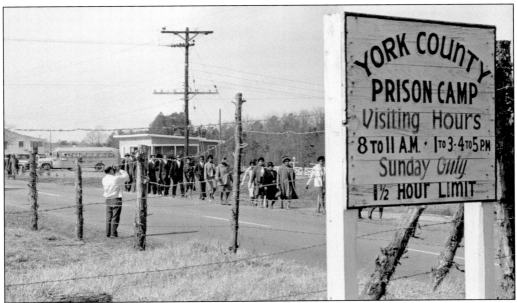

In Rock Hill, South Carolina, sit-in protesters made national headlines with a new tactic. Arrested for requesting food at McCrory's lunch counter, they proudly went to jail. They refused to get out on bail, instead serving 30 days hard labor on the prison work-gang. "Jail, no bail" won nationwide media coverage and was quickly picked up by student activists across the South. Nine from Rock Hill began the protest: John Gains, Thomas Gaither, Clarence Graham, Dub Massey, Robert McCullough, Willie McCleod, James Wells, David Williamson, and Mack Workman. These were soon joined by Diane Nash from Nashville, Ruby Doris Smith from Atlanta, Charles Sherrod from Virginia, and Charles Jones from Charlotte. (Courtesy of the Robinson-Spangler Carolina Room, PLCMC.)

Charlotte's finer restaurants continued to resist desegregation after 1960, sparking more protests. To preserve Charlotte's image as a stable place to do business, Mayor Stan Brookshire arranged for white chamber of commerce members to pair up with black leaders and quietly eat together at downtown restaurants. Brookshire and retired Davidson College president Dr. John Cunningham shared the first meal with Fred Alexander of the NAACP and Moses Belton from Johnson C. Smith University at the Manger Inn on North Tryon Street on May 29, 1963. At a time when many southern leaders resisted Civil Rights, Mayor Brookshire won applause nationwide. (Courtesy of the Robinson-Spangler Carolina Room, PLCMC.)

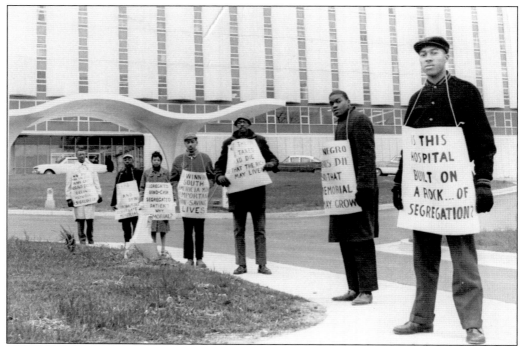

African Americans were denied admittance to Charlotte's Memorial Hospital, despite its receiving large amounts of government funding (money taxed from both blacks and whites). This protest, begun in 1962, succeeded in desegregating the hospital.

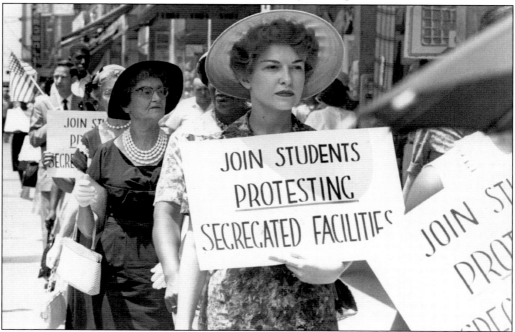

Marchers supporting Charlotte's Civil Rights activists included Unitarian minister Rev. Sidney Freeman, seen carrying the flag.

Born in British Guyana and educated at Oxford and Harvard, Dr. Nathaniel Tross edited *The Charlotte Post* from 1939 into the 1960s. As WBT Radio's only black commentator, Tross was the leader that white Charlotteans heard regularly. He worked quietly for change, notably helping with the hiring of Charlotte's first black police officers. However, when young African Americans began protesting in the late 1950s, Tross publicly opposed them. He urged patience and assured whites that "Rev. Martin Luther King does not speak for the Negroes." Johnson C. Smith students became so angry that they hanged Tross in effigy in 1960. (Courtesy of Jefferson-Pilot Communications.)

A dentist and United Presbyterian minister, Reginald Hawkins made his living entirely from the black community and thus could face whites fearlessly. On July 15, 1954, he and three friends sat down at the whites-only lunch counter in Charlotte's airport—six years before the famed Greensboro sit-ins. Hawkins's efforts got the U.S. Department of Commerce to desegregate the airport's eateries. Throughout the 1960s, Hawkins led protests and filed lawsuits that resulted in the desegregation of Charlotte Memorial Hospital, Mercy Hospital, the North Carolina Dental Society, and the Charlotte YMCA. (Courtesy of the *Charlotte Observer*.)

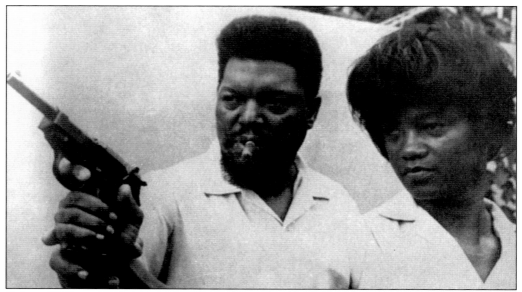

Robert Williams and wife Mabel believed that social change could only be brought about through armed self-defense. President of the Monroe, North Carolina NAACP, Williams organized protests against Monroe's white-only swimming pool in 1957. A year later, he won nationwide attention protesting long jail terms given to two African-American boys, ages eight and ten, for kissing a white playmate. His stands brought armed assaults by the Ku Klux Klan. Williams advocated "armed self-reliance" by blacks, and he and his followers used machine guns, dynamite, and Molotov cocktails to confront Klan terrorists. This made Williams unpopular with many Civil Rights leaders who believed strongly in non-violence. (Courtesy of the John Herman Williams.)

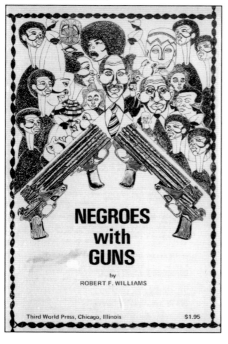

In a 1961 confrontation with the Klan, Williams was charged with kidnapping and fled to Cuba. From there, he and his wife Mabel broadcast a radio show, "Radio Free Dixie," that could be heard as far away as Los Angeles and New York City. Together they published *The Crusader* newsletter and, in 1962, wrote the book *Negroes with Guns*, urging African Americans to arm themselves—writings that Malcolm X later remarked placed Williams "just a couple of years ahead of his time" and helped inspire the Black Power movement of the late 1960s.

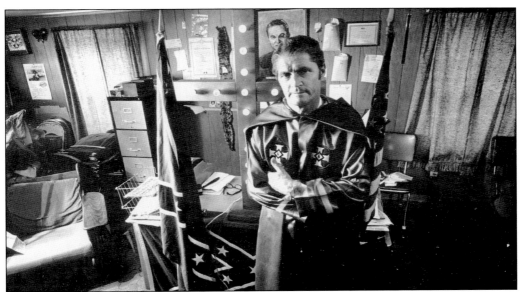

Grand Dragon of the South Carolina Ku Klux Klan from 1961 to 1969, Robert Scoggins led KKK rallies and marches, printed materials, and burned crosses in order to stir white resistance to integration and "race mixing." Scoggins grew up on a cotton farm in Polk County, North Carolina, west of Charlotte. Like many Carolinians, he left the farm as soon as he was old enough to find a job, signing on at a textile mill in Spartanburg. After serving in World War II, Scoggins joined the Klan in 1955 "to restore the government back to the Constitution." He rose to become Grand Dragon, which he remained until 1969, when he was convicted of contempt of congress and jailed in federal prison for one year. (Courtesy of the Scoggins family.)

Sen. Sam Ervin of Rutherford County became one of America's best known political leaders during the 1970s as chair of the Watergate Committee investigating President Richard Nixon. Ervin made his name previously as an opponent of Civil Rights laws, saying that such powers were not given to Washington by the U.S. Constitution.

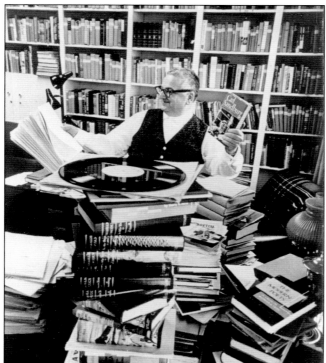

Charlotte newspaperman Harry Golden used humor as a weapon to attack the South's "separate but equal" policies. For instance, African Americans were not allowed to sit down and eat in restaurants, but no one minded when blacks and whites stood together in store check-out lines. So, in his *Carolina Israelite* newspaper, Harry proposed his "Golden Vertical Plan": remove the seats from all restaurants, make everyone eat standing up, and presto—instant trouble free integration! (Courtesy of UNC Charlotte, Special Collections.)

Eleven years after *Brown* v. *Board of Education* ended school segregation, nearly all of Charlotte's African-American pupils still went to predominately black schools. Vera and Darius Swann filed suit asking that their son James be admitted to predominately white Seversville School, closest to their home near Johnson C. Smith University. Charlotte Civil Rights lawyer Julius Chambers argued the case: *Swann* v. *Charlotte Mecklenburg Board of Education*. (Courtesy of the *Charlotte Observer*.)

Attorney Julius Chambers had graduated first in his class from UNC School of Law in 1962, then worked on the staff of the NAACP Legal Defense Fund, before starting his own firm in Charlotte. Shortly after filing the *Swann* suit, his home was bombed. (Courtesy of the Robinson-Spangler Carolina Room, PLCMC.)

In 1969, Federal Judge James McMillan of Charlotte ruled in favor of the Swann family and insisted that desegregation must move forward. He urged the school board to consider cross-town busing. McMillan knew the well-built schools were usually in the white southeast neighborhoods; sub-standard ones were often in black north and west neighborhoods. Busing could overcome that inequality. (Courtesy of the *Charlotte Observer*.)

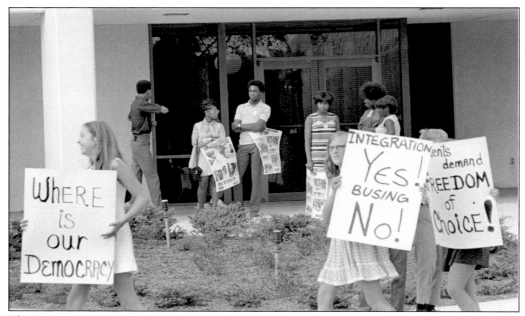

The *Swann* case was appealed to the United States Supreme Court. The months between Judge McMillan's original decision and the Supreme Court's ruling were tumultuous for Charlotte, as indicated by these photographs of protesters outside of the Mecklenburg Education Center. In 1971, the high court agreed with McMillan that busing was a proper remedy. The *Swann* decision became the national model for court-ordered busing to achieve racial desegregation. (Above and below, courtesy of the Robinson-Spangler Carolina Room, PLCMC.)

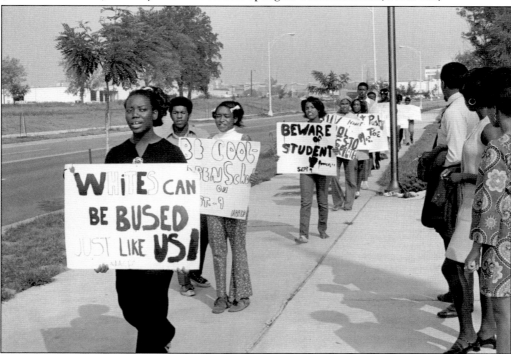

When the U.S. Supreme Court ruled that busing must go ahead in Charlotte, Maggie Ray showed the way. Charlotte's first busing proposals exempted well-to-do white neighborhoods. To Maggie Ray and many others, this did not seem fair. A Citizens Advisory Group formed with Ray as the co-chair. She began inviting people from every neighborhood to dinner meetings, "since people in the South seem to feel you have to be friendly at mealtimes," she said. Together, they hammered out a busing proposal that involved all neighborhoods. The 1974 plan guided Charlotte-Mecklenburg schools for the next 25 years. (Courtesy of the Robinson-Spangler Carolina Room, PLCMC.)

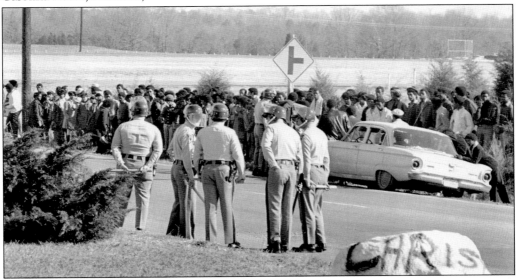

Violence and vandalism did occasionally mar the busing efforts. Here, police officers deal with a 1971 student riot at a Charlotte high school. (Courtesy of the Robinson-Spangler Carolina Room, PLCMC.)

Harvey Gantt first made headlines when he sought to enter Clemson University. He wanted to study architecture and Clemson had the only architecture school in his home state of South Carolina. In 1963, he became the university's first African American student. After graduation, Gantt opened his architecture office in fast-growing Charlotte. In 1974, he won a seat on city council and in 1983 he became mayor, making Charlotte the largest majority-white city in the United States to elect an African-American mayor. (Courtesy of the *Charlotte Observer*.)

In today's South, school students are no longer just black and white. Pupils in Charlotte-Mecklenburg Schools speak 83 languages and hail from 102 native countries. (Photo taken at Eastway Middle School in 1999 by Nancy Pierce.)

Seven

BANKING BOOMTOWN
1970s–2000s

Reinventing itself once again, Charlotte emerged as a banking center. What had been a tiny farm village in 1865 and a regional textile town in 1920, ranked as America's second largest banking city by 2000. Growth transformed the Piedmont—not just Charlotte, but all the surrounding counties—as newcomers arrived from across the United States and around the world. Mill villages became commuter suburbs. Farmland sprouted houses and malls. How would this region handle the challenges that came with such rapid change? (Photo by John Hilarides.)

The first discovery of gold in the United States launched Charlotte into banking. In 1799, 25 miles east of Charlotte, a 12-year-old farm boy named Conrad Reed (left) stumbled across a 17-pound gold nugget. The family used it as a doorstop until a jeweler offered to buy it for $3.50—he turned it into a bar worth $3,600. Small mines soon pockmarked the Piedmont. (Courtesy of the Reed Goldmine Historic Site.)

Charlotte became the trading town for the gold region. A branch of the North Carolina Bank opened in Charlotte in 1834 and a United States Mint was built to strike coins from Carolina gold. The Mint building stood at the corner of Mint and West Trade Streets until the 1930s when it was taken down and reconstructed in the suburbs as the Mint Museum of Art. (Courtesy of the Levine Museum of the New South.)

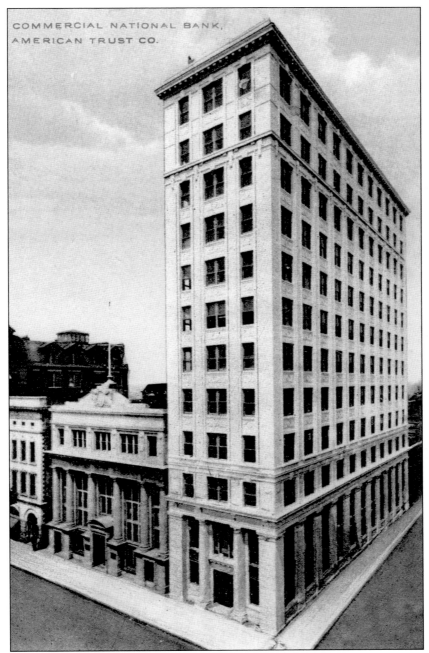

COMMERCIAL NATIONAL BANK,
AMERICAN TRUST CO.

Banks stayed small until the textile era. Bank of America's Charlotte roots began with Commercial National Bank (above, right), founded in 1874 by William Holt, who owned the busy Glencoe Cotton Mill of Burlington, North Carolina. The family who manufactured Draper textile machinery co-founded American Trust (above, left), located next door. The two banks merged in 1957 and soon took the name North Carolina National Bank. NCNB became Nations Bank, then Bank of America, the largest consumer bank in the United States. (Courtesy of Mary Boyer.)

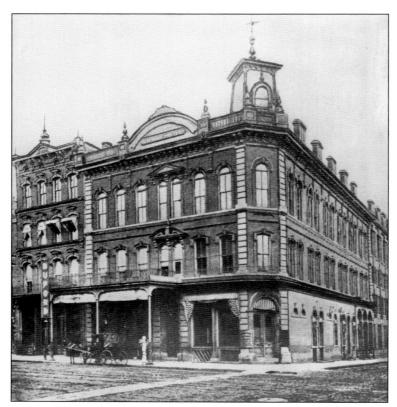

First Union was also tied to wealth generated by Piedmont textile mills; president and leading stockholder T.W. Wade was a wealthy Charlotte cotton broker. The bank started in 1908 as Union National Bank in the Buford Hotel on Tryon Street; the building was razed in the mid-1960s. (Courtesy of First Union.)

Wachovia Bank and Trust, based in Winston-Salem, bought Charlotte National Bank in 1939, thanks to North Carolina's laws that allowed statewide branch banking (forbidden in most states). This kicked off a fierce rivalry with Charlotte's hometown banks. After decades of competition, First Union and Wachovia merged in 2001. (Courtesy of the *Charlotte Observer*.)

In 1927, the U.S. Federal Reserve chose Charlotte as the site for its branch serving the Carolinas. The Federal Reserve is the bridge between banks and the federal government. It puts new dollar bills into circulation and shreds old ones. It also "clears" checks—gets a check written anywhere in the Carolinas back to its home bank. Fast access to "the Fed" gave Charlotte banks strong advantages over banks farther away. (Courtesy of the Levine Museum of the New South.)

This woman is clearing checks at the Charlotte Branch of the Federal Reserve in the 1970s. (Courtesy of the Federal Reserve.)

Until the 1980s, laws in every state required that banks be locally owned to make sure banks focused on local community needs. Laws also forbade banks from owning other types of financial institutions, like stock brokerages and insurance agencies. In 1968, First Union president Cliff Cameron (above) devised a way around the laws limiting a bank's reach. He created a non-bank "holding company" that owned First Union National Bank plus other financial businesses that the bank could not legally own. (Courtesy of First Union.)

Before computers, banks had to track every transaction—millions of bits of data—by hand. Two important steps in the banking industry's computer revolution occurred in Charlotte. In 1978, IBM invented the first "on-line" ATM at their facilities near UNC Charlotte. The IBM 3624 (pictured here) allowed banks to monitor deposits and withdrawals 24 hours a day by computer. In 1986, First Union became the first bank in the nation to link its branches by satellite, enabling computers to transmit data instantly. (Courtesy of the IBM Corporate Archives.)

With technology now becoming available to operate distant branches, Tom Storrs and Hugh McColl took the holding company idea and ran with it. In 1982, their NCNB holding company bought Lake City Bank in Florida. Here, Hugh McColl (left) and staff plant the Florida state flag "Iwo Jima–style" in the NCNB conference room. For the first time, an American bank crossed state lines. The move opened a new era—local banks would give way to large multi-state corporations. (Courtesy of Bank of America.)

Charlotte's head start in smashing the interstate banking barrier gave it powerful momentum. Through the 1980s and 1990s, the city's two top banks, led by rivals Hugh McColl of NationsBank (left) and Ed Crutchfield of First Union (right) competed to buy up out-of-state financial institutions. Because of these efforts, Charlotte now ranks second only to New York as America's banking hub. (Courtesy of Nancy Pierce and the *Charlotte Observer*.)

In 1998, Charlotte astounded the world when Hugh McColl bought California's venerable giant Bank of America. The resulting company took the California name, but its headquarters would be in Charlotte, in the tower that most defines the Queen City's skyline. The South—once America's poorest region— was now home to the first coast-to-coast bank in the United States. (Courtesy of Richard Starling.)

Soon after Ed Crutchfield retired, the First Union name was retired, too. In 2001, First Union announced plans to buy its old rival, Wachovia Bank of Winston-Salem. The corporation, now the fifth largest bank in the United States, took the Wachovia name, and like "B of A" kept its headquarters in Charlotte. (Courtesy of Rick Alexander and Associates.)

According to mayor John Belk, "What the railroad was to Charlotte 100 years ago, the airport is today." A new terminal opened at Douglas Municipal in 1954 and in 1982 the current terminal was built. By 2000, Charlotte Douglas International was the country's ninth busiest airport, handling 5,000 flights each day. (Courtesy of the Levine Museum of the New South.)

Prosperity and growth and are not without their consequences. Piedmont cities have sprawled outward, swallowing up farmland and smaller communities. These two photos show Interstate 77, exit 25 at Huntersville, until recently an area of farms. Between 1989 (top) and 1998 (below), the area sprouted shopping centers and cul-de-sac neighborhoods and became known for traffic congestion. (Courtesy of the Crosland Group.)

The Charlotte population doubled between 1970 and 2000—making it the second fastest growing city in the United States. People from all over the country and immigrants from around the world moved into the Carolina Piedmont, bringing new ideas and customs. In Charlotte and Mecklenburg County, there are now over 34,000 Asians, and the Latino population shot up from about 6,700 in 1990 to 60,000 by 2000.

Once a rarity, immigrant-owned businesses are now quite visible in Charlotte, especially along Central Avenue and South Boulevard. Two good examples of how new arrivals are enriching Charlotte are the Asian Market and Seafood (above) and the Panaderia La Mexicana (left), both on South Boulevard. (Courtesy of Nancy Pierce, 2001.)

ACKNOWLEDGMENTS

We stand on the shoulders of giants; the work of historians such as LeGette Blythe, Dan Morrill, David Goldfield, Pamela Grundy, Frye Gaillard, Mary Kratt, Lois Yandle, and Vermelle Ely greatly informed the museum's exhibit, and by extension, this volume. We would like to thank the invaluable staff of the Robinson-Spangler Carolina Room—especially Shelia Bumgarner, Pam Rasfeld, Jane Johnson and Rosemary Lands, who took a great interest in this project and were always ready with assistance and advice. We are very grateful to Davie Hinshaw and Anne Bryant at the *Charlotte Observer* for giving us access to their photographic library. As always, Robin Brabham and Pat Ryckman at UNC Charlotte Special Collections were a tremendous resource for research and images. The Charles A. Cannon Memorial Libraries in Concord and Kannapolis were very helpful, especially Norris Dearmon and Terry Hayer. Dennis Lawson at Duke Energy's corporate archives and Darrell Williams at the archives of Belk, Inc. gave us gracious access to their holdings. Kugler Studios has preserved much of Charlotte's history and Ken Bebee generously allowed us to use some of their work. This project would not have been possible with out the help of numerous individuals who took their time to share their memories and family photographs with us.

The exhibit "Cotton Fields to Skyscrapers: Charlotte and the Carolina Piedmont in the New South" at the Levine Museum of the New South was first envisioned by Sally Robinson, Robert Weis, and Dr. Bren Martin with assistance from Staples & Charles Design, under the leadership of the museum's executive director Emily Zimmern. Thanks to all who helped bring the project to reality, including Jean Johnson, John Hilarides, Tina Wright, and Cathy Grybush, and to major funders: Bank of America, Belk Foundation, City of Charlotte, First Union Foundation, National Endowment for the Humanities, Bovis Lend Lease, Inc., Cato Corporation, Charlotte Pipe and Foundry, Duke Energy Foundation, Wachovia Bank, and Museum Loan Network.

Tom Hanchett, staff historian
Ryan Sumner, assistant curator